Melee is Broken

Super Smash Bros. Melee:
An Interdisciplinary Esports Ethnography

AJ "spoopy" Rappaport
Nicole "st. nicholas" Bennett

Melee is Broken

Super Smash Bros. Melee:

An Interdisciplinary Esports Ethnography

Primary author, artist, designer, layout

AJ "spoopy" Rappaport (they/them)

Secondary author, critique partner and editor

Nicole "st. nicholas" Bennett (she/her)

ISBN: 978-1-716-45930-6

© 2020 by AJ Rappaport

Some rights reserved

This work is licensed under a Creative Commons

Attribution-NonCommercial-NoDeriatives 4.0 International License

Cover design and all images by AJ Rappaport

Printed and bound by Lulu Press, Inc., USA

III

Acknowledgments

I developed this work for my Individualized Masters at Concordia University in Montreal, Quebec, but it has always been, at its heart, for the *Super Smash Bros. Melee* (*SSBM*) community.

There are many people I need to thank for this project, but I'd like to begin by acknowledging that Concordia University is located on unceded Indigenous lands. The Kanien'kehá:ka Nation is recognized as the custodians of the lands and waters on which we gather today. Tiohtià:ke/Montréal is historically known as a gathering place for many First Nations. Today, it is home to a diverse population of Indigenous and other peoples. I respect the continued connections with the past, present and future in our ongoing relationships with Indigenous and other peoples within the Montreal community.

Thank you to my advisors: Dr. Darren Wershler, Dr. Bart Simon, Dr. Rilla Khaled and Dr. Pippin Barr. Thank you to everyone at the Milieux Institute for Arts, Culture and Technology and the Media History Research Centre for giving me a space to belong to during my Masters. I am grateful for the opportunities that came from working as a research assistant at the Residual Media Depot (https://residualmedia.net/). Thank you to my esteemed colleagues and friends Alex Custodio and Michael Iantorno for supporting me and helping me immensely as I completed this work.

Acknowledgments

Finally, I want to thank Nicole for coming onto this project as a secondary writer, editor and contributor. Once we started working together, I could not see this project being completed without her. I am eternally grateful for our teamwork and friendship, which have only been strengthened by this special project.

A huge shoutout to my family for their infinite support and love, always. Shoutout to all my gamers and "homies" for their everlasting friendship. Finally, thank you to *SSBM* for years of competition, excitement, and epic gameplay. Here's to many more.

Contents

Acknowledgments . IV

Foreward . 5

I. Introduction . 9

II. Method . 13

 Prologue: Collective Nostalgia 20

 Artist's Statement: Basement Melee 23

III. Hardware & Software 26

 What is *SSBM*? . 26

 Adversarial Esports Shaped by its Players 29

 What Lag is for *SSBM*: The CRT Debate 34

 2 Consoles, 1 Experience 37

 Adherence and Love for the CRT 39

 Reframing the Debate: A Software Issue 43

 Embodied Play: Adapting Body to Hardware 45

 Snapback and UCF . 47

 Controllers, But Make it Fashion! 52

 Frankenstein Controller: Artist's Statement 53

IV. Discourse . 56

Where and How Discourse Forms 56

Broken & Balanced . 60

Discourse for Gameplay 62

Development of Universal Rules 65

Power & Responsibility 68

Discourse Formation by Authority 70

Performance . 70

Timelining History & Discourse 76

Player Spotlight: PPMD 84

It Matters to Be Here . 87

Being There: Reflections on Genesis 7 89

V. Technique . 97

Examining *SSBM* Technique, Culture and Infrastructure . . 97

Hidden Competitive Potential: The Beginnings 100

Artist's Statement: What You See Isn't What You Get . . 102

Practice Makes Perfect 104

Movement and Defensive Techniques 106

Player Identity Through Technique 108

Case Study: *Wobbling* 112

Acknowledgments

- Homosociality, Gender and Technique 116
- Homosocial Technique Constructed by Players 122
- Case Study: Drinking Culture 123
- *Money Matches* and Meritocratic Ideals 126
- Homosocial Control Techniques: Trash Talk 130
- Resistance to Homosocial Discourses 133
- Continuing to Resist and Grow 136
- Artist's Statement: The Wholesome Gaming Manifesto . 139

VI. Conclusion . 145

Afterword . 149

Works Cited & Bibliography 154

About the Author & Artist . 165

Foreword

The bulk of the research and writing that went into this book originally took place from 2017 to early 2020 while I was pursuing my Individualized Master's degree (INDI MA) at Concordia University, concluding right before the onset of the COVID-19 pandemic in March of this year. Much like many other professions and events, *SSBM* has undergone dramatic changes since: all in-person tournaments have been either put on hold indefinitely or outright cancelled, and as a result, virtually all competitive play is done online through the emulator software Dolphin—the practice of connecting remotely with another player through Dolphin is referred to as *netplay*. In June of this year, Project Slippi, an initiative headed by programmer Jas "Fizzi" Laferriere, debuted a modification that changed the existing delay-based netcode Dolphin uses to prevent latency to *rollback*, which many players perceived to be a massive upgrade in terms of latency, quality, and the potential for play across states or even countries. It would be remiss of me not to acknowledge Fizzi and his team's efforts in this book, for this one change dramatically increased interest in competitive *SSBM* during an otherwise unprecedentedly slow and uncertain time for the competitive *SSBM* scene at large. Ultimately, however, what you are about to read develops an ethnography of competitive *SSBM* before the COVID-19 pandemic and the

era of Project Slippi, although there are a lot of notions and ideas discussed in this work that remain timeless and eternally relevant to our understanding of video game history.

While this book is an adaptation of my master's thesis, in preparing it, I sought to create a thoughtful and engaging ethnography of the competitive *SSBM* scene that wasn't exclusively accessible to academics or to those already within the scene. I encourage *SSBM* enthusiasts and players to recommend this book to their families or friends, even those on the peripheral of gaming culture, so that they can learn about and come to understand why *SSBM* is such a unique case in esports and why people are still so passionate about it nearly two decades after its release—I don't think one has to know everything there is to know about either the world of academia or that of esports and gaming to get to know this amazing game and its community.

Many unfamiliar with *SSBM* may dismiss the player-cultivated techniques such as *wavedashing* or *shield-dropping* that I'll discuss later on as mere "glitches" or "exploitations", but to me, they signal the extent to which *SSBM* players and enthusiasts have pushed the limits and constraints of this aging game and, to this day, continue to do so. In my own art practice, I often add constraints to whatever I'm working on such as using a limited color palette or restricting myself to certain materials; I find that constraints like these scaffold grounded creative production, much like how only immense pressure can turn coal to diamonds, and enable me to create more interesting

work. *SSBM* has flourished under so many competing pressures and limitations, both in and out of the game, and the ways in which *SSBM* players and enthusiasts have investigated and developed the game never fail to astound me. I hope this book demonstrates how *SSBM* continues to thrive under unique constraints, a notion that I believe can make something truly remarkable.

Melee is Broken

I. Introduction

When Nintendo released *Super Smash Bros. Melee* in 2001, they intended for it to be a casual, family-friendly party game: in a recent interview, Masahiro Sakurai, the game's director, stated that the way competitive *SSBM* players use the game today doesn't align with the series' values, nor is it consistent with Nintendo's broader philosophy, which positions games as designed for casual rather than competitive play (Doolan). Until the fifth installment of the community-ran Apex esports tournament in 2014, Nintendo actively denied any form of support to competitive *SSBM* players, and, even then, their reaction to *SSBM*'s growth as an esport and competitively played game has proved antagonistic. Notably, this long-standing tension between the game's player base and its developers runs contrary to most esports, which are designed specifically for competitive play at a professional level.

The other key element of competitive *SSBM* play that sets it apart from other esports is players' continued reliance on hardware objects from the early 2000s—namely the cathode-ray tube (CRT) television, specific gaming consoles, and personal GameCube controllers. At release, *SSBM* required a Nintendo GameCube, its attending power and RCA cables, a game disc, a GameCube controller, and a CRT television. *SSBM* players still use this *setup* today, albeit often including several community-built add-ons and modifications. As a

result of their ongoing reliance on the affordances of these particular tools, the *SSBM* community breathes new life into ostensibly "dead" media objects, replicating the practice described by media scholar Raymond Williams of keeping meanings and values alive by individuals, social inheritances, and embodied knowledge; as they're learned, these meanings and values become universalized (Williams).

Consequently, I argue that *SSBM* is a unique and important case study in esports media history. Its community of competitive players and spectators is unusual for two reasons: its continued relationship to residual hardware and the fact that the narrative of the game and community is built by players rather than developers. My own ongoing participation in the community, combined with my artistic practice, academic experience and queer identity allows me to write from a position that is both critical of and sensitive to the nuances of competitive *SSBM*. The aim of this project, in short, is to produce a cohesive study of *SSBM* culture through interdisciplinary research.

In order to properly examine and describe this exceptional game and its community, I begin by investigating its hardware and software, as well as the ways in which the community continues to operate within the constraints of residual media in order to realize the competitive scene. The ideologies and principles that sustain competitive *SSBM* can also be traced through examining community discourse and the various techniques both in- and out-of-game that players

I. Introduction

perform and circulate. Discourse in this context refers to the ways in which a given group discusses their experiences and feelings—as well as what they purposefully leave out of the discussion.

In writing this book, I made careful choices about what to discuss and what to omit in order to disrupt some of the power relations at play in the larger *SSBM* community. There exist many interpretations and narrativizations of *SSBM*'s history, many of which are celebrated by the community at large. As certain narratives and knowledges have gained relevance and significance over others, they inevitably overshadow what isn't as apparent to the overall community (e.g., the inner workings of tournaments, the code of the game, alterations to said code, the contracts of sponsored players). As will be discussed towards the end of this book, expert players and other community figureheads have historically obfuscated this information to some extent as a means to optimize their own gameplay, to retain power and expertise within the community, or simply to maintain the status quo. We can see how this phenomenon operates in the tension between the *SSBM* community and Nintendo, because the latter opposes many of the alterations to the game that the former makes; those "in the know" are forced to circulate knowledge amongst themselves in order to conceal alterations from the developer, and this indirectly imposes a limitation on the extent of non-expert players' knowledge.

Moreover, most documentation of *SSBM* and its community

often prioritizes discussion of more readily accepted subjects like gameplay, tournaments, and tier lists, overlooking more nuanced subjects of discussion such as issues of discrimination and ostracization in the community. As a scholar and artist, as well as a community member, as much as I strive to respect the community, I also strive to produce honest work. To that end, I argue that it's important to reflect on situated power in the community and to address gaps in the discourse in order to think about how we might challenge gatekeeping to improve *SSBM*'s accessibility.

II. Method

This study employs qualitative research methods, such as ethnography, auto-ethnography, media archeology, and research-creation. I begin with a broad research question: what is competitive *SSBM* culture? To uncover this culture, I take the community's material objects as my point of departure, performing an analysis of *SSBM*'s hardware and software objects. My approach draws on media-archaeological methods to produce a robust analysis of the hardware's specifications, affordances, and constraints. Media archeology can present new futures based in fluid, temporal and spatial analyses of a given medium. Although media archaeology is a broad field that invites a variety of theoretical approaches, one common thread is the invitation to study media outside linear narratives of progress. Studying *SSBM* as a constellation of hardware—rather than as a timeline toward technological innovation—allows me to map the relationships between objects and people and between objects and other objects in order to reveal the ideologies at (literally and metaphorically) play.

Following this material analysis, I look at the discourse around these objects to perform a qualitative analysis of the community's vocabulary by isolating salient terms, including: lag, CRT, *broken*, balanced, *johns*, *campy*, aggressive, and ruleset. These are all

common terms in the community's lexicon, and I focused specifically on usages of them by popular community figureheads in order to construct proper definitions of them for this book and produce a map of community vocabulary. My analysis of these terms and their usage reveals different ideologies at play in the community, as well as the community's many sources of power—later on, I examine how gender and masculinity specifically are constructed within *SSBM*'s predominantly homogeneous environment, for example.

The community developed their own intended uses for *SSBM*'s software and the hardware on which it runs. Siegfried Zielinski argues that media artifacts are mechanisms for demonstrating perception (Zeilinski). Artifacts like *SSBM*'s hardware demonstrate how communities develop in tension with Nintendo and also how community discourse directly influences community practice. By analyzing not only community techniques but also the way that community members discuss such techniques, we can trace the embodied practices that coalesce to create *SSBM* culture. Please note that *SSBM* culture here refers to the culture that exists on a global level, spanning many individual self-defined regions, within the competitive *SSBM* community, which itself exists under the umbrella of the greater global competitive *Smash* community, a label which encompasses communities that play any game in the *Smash* franchise seriously or competitively.

Two terms extremely pertinent to understanding *SSBM* culture are *grassroots* and *esports*. These are not terms exclusive to *SSBM*

players—every competitive video game's community has considered and discussed these terms to some extent. They signify opposing directions: to be *esports* is to rely on outsider-supported infrastructure in order to maintain a professional, polished aesthetic, whereas to be *grassroots* is to reject the corporate attitude—and, by extension, the money—that being *esports* provides in favor of a more tight-knit, community-led space.

Given the importance of the community-built *grassroots* infrastructure to understanding *SSBM*, it is imperative that scholars use the tools that players spent years developing in order to understand the culture that simultaneously gave rise to and emerged from said tools. To achieve that, I consult the most popular and widely accepted online text-based resources for *SSBM*: Melee it on Me (MIOM), Smash Wiki, MeleeLibrary.com, and Smashboards. As community projects, these sources are crucial for understanding community discourse, practices, and techniques. In addition to written text, I refer to key video resources, such as popular YouTube channel "SSBM Tutorials" and (in)famous documentary *The Smash Brothers* (Beauchamp). I pair these sources with my own personal experience as a lifetime player and *gamer*. I have played (video) games as long as I can remember, and as I nestled into the *SSBM* community I took on the label of *gamer*, identifying myself as someone seriously passionate about gaming culture, lore and news. One way in which I, along with virtually everyone else in the competitive *SSBM* scene, cement my claim to the identity of *gamer* is through adopting a *tag*——a moniker

specifically created for use within the scene both in and out of game. It is common courtesy in the competitive *SSBM* scene to refer to all *SSBM* community members, enthusiasts, or players that one does not know personally by their *tags* as opposed to their first names; so as to adhere to this tradition, I will include the *tags* of community figures when mentioning them in this text whenever possible.

Since early 2015, I've been an active participant in the competitive *SSBM* community and have attended tournaments and events of all sizes around North America. For over half a decade, I've organized tournaments, volunteered and competed at various tournaments, created artwork and designs for events, and attended at least two *majors*—that is, large-scale tournaments with upwards of two thousand attendees—each year.

That said, my experience of *SSBM* is largely based on being a fan of the game. Creating work as a fan can run the risk of eclipsing critique and critical thought in favour of fandom and love. Video game designer and media scholar Ian Bogost notes that there is a risk that comes with writing about and critiquing the things of which one is a fan, the most obvious being the tendency to merely repeat similar ideas without creating new content. Bogost points to the concept of the aca-fan—"a hybrid of academic and fan critics that acknowledges and interweaves both intellectual and emotional cultural engagements" (Bogost)—and encourages aca-fans not to ignore the discomforts they may uncover in researching their beloved topic of study. By challenging the work rather than merely praising it, aca-fans

can produce more cohesive and well-rounded study.

In an effort to follow this approach, I pair my academic work with my artistic practice to produce an interdisciplinary research object. My art practice emerges out of experiences with the tactility of *SSBM*. As an artist, it is important to me that my research extends beyond mere textual analysis to question the materials, images, and discourse of *SSBM* culture through research-creation. Research-creation here refers to the practice of non-traditional research that extends beyond academic conventions, whereby objects or topics are investigated through observation and creation. In so doing, I not only bring a new perspective to the study of esports, but also produce an interdisciplinary work that is approachable and that invites deeper sensory engagement.

Because *SSBM* is deeply rooted in specific material hardware objects, I draw my theoretical framework primarily from media archaeology. Under this umbrella, Jussi Parrika and Thomas Apperley posit that art and critical design practices are useful methods for interrogating a platform's perceived uniformity (349-369). Moreover, Thomas Elsaesser's study of media archeology as symptom suggests that media archeology can allow scholars to shift from traditional linear storytelling to instead uncover patterns in media history (Elsaesser). For instance, many players, gaming enthusiasts, and self identified *gamers* have had access to *SSBM* around the world, but it is the particularized and precise use of *SSBM* that differentiates the competitive community.

Today, as a networked community, the communal space (or non-space) of competitive *SSBM* often feels ephemeral because it exists on a global scale. Media archeology is a fitting research tool because of my ongoing imperative to grow personal collections and reorganize the spaces they occupy constantly. Most esports communities lack geographical space that defines them, and thus remain predominantly virtual. While the physical gathering at any esports event emphasizes the need for literal touch, competitive *SSBM* seems to have an imperative for touch, gathering, and kinship more so than most esports, a deeper reliance on in-person play for optimal play or the *feel* of the game, a concept I'll discuss further in the technique section.

Finally, I have organized this project into a book format. I have a background in book/print making and believe it's an effective way to present information, while inviting a specific experience that I feel is lacking in academic texts, from my perspective as a visual learner. Intertwining my art practice with academic writing not only benefits the visual learner and allows for wider interpretation than text alone could offer—it also infuses my own individuality into the text, allowing me to conduct somewhat of an auto-ethnography.

Most public presentation of esports (e.g., broadcasts) favours slick, professional coverage, a luxury afforded to them through the financial backing of large sponsors. Much of the existing documentation of *SSBM*'s existence as a competitive game and its community inherently rejects or avoids this aesthetic as part of paying homage

II. Method

to the competitive *SSBM* scene's *grassroots* history. It also focuses primarily on recounting history or discussions of gameplay. This book aims to add an emphasis on community practice, including the techniques and protocols that happen away from the screen, to the greater conversation on *SSBM*. The combination of textual analysis and research-creation results in esports research presentation both intimate and innovative in its intimacy, in order to address what has not yet been said about *SSBM*: the sense of individuality required to compete, the performative aspects of competing, the weight of (inter) actions outside of play.

Prologue: Collective Nostalgia

The rise of esports and professional gaming is now a fixture of Western society (Yao). 2019 marked the 18th year since the release of *SSBM*—its "18th birthday"—a milestone perceived by many to mark the beginning of adulthood. To reach this milestone, one must undergo growth and fundamental challenges; much like how humans struggle with a myriad of trials and tribulations to achieve maturity, *SSBM* and our understanding of it has been subjected to countless changes over time.

Many *SSBM* players regard the game's genesis as having taken place in a simpler time. The game's infancy was exciting. The cast of characters in *SSBM* more than doubled the amount from its predecessor, *Super Smash Bros.*, continuing the mashup of a wide range of Nintendo properties (at the time of release), including *Super Mario*, *The Legend of Zelda*, *Pokémon*, and *Fire Emblem*. In Mio Bryce's study of cuteness as a communication device, they explain that Japanese cuteness often exhibits strong fluid hybridity, encompassing many visual themes or motifs into one image or work, and we can see this hybridity demonstrated in the design choices made for a lot of the elements of the game—like the virtual collectables, battle items, music, and stage design—which were intended to appeal to children. Moreover, Bryce proposes that cuteness manifests from

II. Method 21

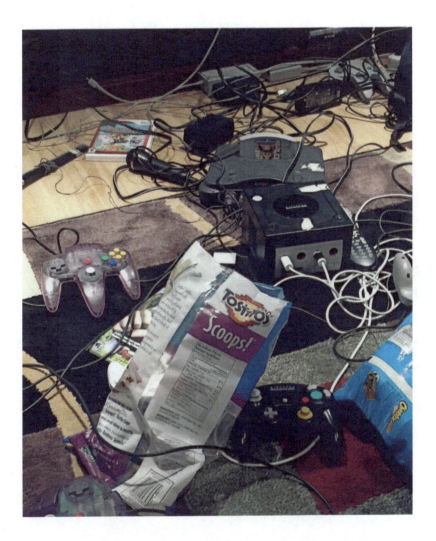

Playing *Smash Bros.* in the basement (circa 2016).

incompleteness; therefore, *SSBM* can only be considered "complete" by means of participation. Ultimately, Bryce states that "cute" often means childlike, and children were Nintendo's intended audience for the game, like most games of the decade. The cartoon stylization of the game, coupled with the inclusion of recognizable Nintendo characters like Mario and Link, made the game accessible to youth. Many competitive players and *SSBM* enthusiasts acquired the game during their childhood or adolescence—as these players grew up, their understanding of *SSBM* and willingness to push its limits grew with them. The ties to the game formed in childhood that so many players have inspires nostalgia in them later in life, especially given the game's reuse of aged but familiar hardware. When compared to many contemporary high definition AAA games, the cute and chunky aesthetics of *SSBM* set the game apart from dominant esports iconography and perception.

Artist's Statement: Basement Melee

To pay homage to *SSBM*'s *grassroots* beginnings, I have created a maquette of the typical gaming space. The work's small scale references the game's use of cuteness as a communication tool. The entire sculpture rests on a cloud-like structure, representing the game's foundation in dreamlike nostalgia—defined by Svetlana Boym as a longing for lost place or time. I want to express the nostalgia I feel for the game's beginnings in the family home, at friends' houses, after

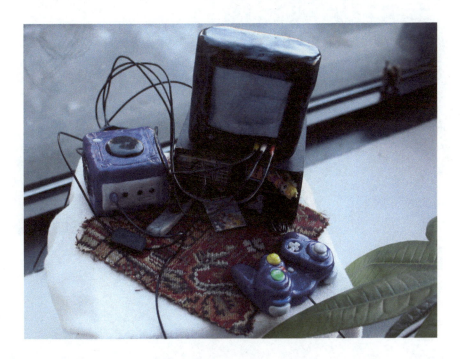

school. I long for a simpler time before players began to discover *SSBM*'s competitive potential. Many competitive players have been playing *SSBM* since the day the game was released, without the goal of defining or achieving standards of either professional competitive play or esports aesthetics in mind. *SSBM* represents the collapse of narrative and nostalgia into a singular form, which is shown in the singularity of this artwork.

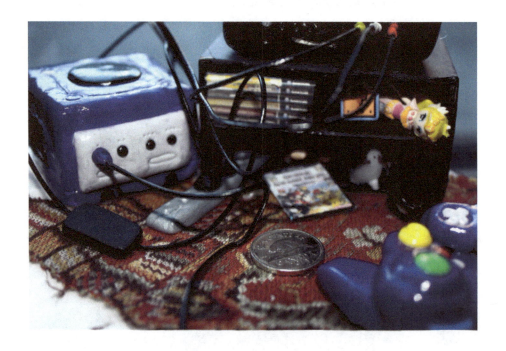

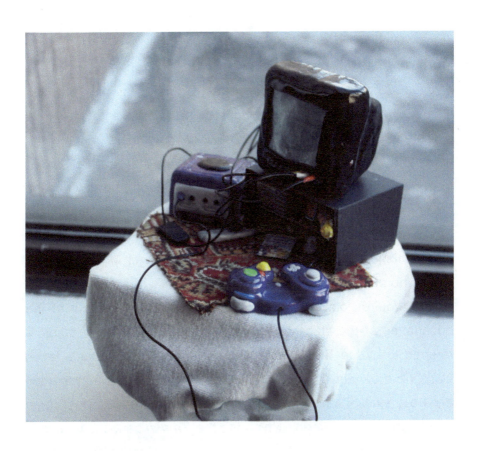

III. Hardware & Software
What is *SSBM*?

In 2001, Nintendo released *SSBM*, the second installment of the beloved *Smash* platform fighting game series, for the Nintendo GameCube. The game features a cast of 25 characters from a variety of Nintendo franchises, including the 12 cast members from the first game and 13 newcomers. One major difference that set *SSBM* apart from most other fighting games was the decision to borrow familiar faces from existing franchises as opposed to designing new characters specifically for the game. Moreover, *SSBM* gameplay differs from canonical fighting games like *Street Fighter* or *Mortal Kombat*, where the objective is to deplete the opponent's health bar. Instead, *SSBM* requires players to knock their own opponents out of the boundaries of the stage to take a life; each life a player takes is referred to by the *SSBM* community as a *stock*. Each battle takes place on a variety of stages designed according to the properties and aesthetics of each franchise, and many feature platforms, some which move or transform. Unique to the *Smash* series, character's damage taken is measured in percentages. Damage dealt one's opponent increases their percentage. The higher one's percentage, the further they get knocked backwards when damage is dealt to them. When a character is forced off the stage and cannot recover, it results in a loss of a *stock*. It is worth noting here that one of the

game's features is a gravity system that sets different weights for each character. Finally, unlike other fighting games, where moves are defined by pre-set combinations of button inputs, moves for *SSBM* are formed with single button presses, often accompanied at most by a single directional input. Memorized sequences of buttons are rare.

This unique form of gameplay provides players with the opportunity for new game plans that are entirely based on forcing their opponent offstage and keeping them there. This is called *edge-guarding*, and it is a crucial technique in *SSBM* competitive play.

SSBM's battle mechanics serve as the core of the game. In addition to this, *SSBM* brought to the table new features—gameplay modes and collectables—unseen in its predecessor. Single-player gameplay modes featured a series of challenges, boss battles and minigames. Although they were included in the previous iteration of the *Smash* series, *SSBM* added new items—also called hazards—that could be turned on prior to gameplay. The range of items is diverse and each one possesses unique effects, such as inflicting damage or restoring health. Moreover, other new features included the ability to adjust damage ratios, coin matches (a mode where players must collect the most "money" possible, where each confirmed hit results in coins flying out of the character taking damage), and a tournament mode. Finally, *SSBM* also required that the player complete several of these challenges in order to unlock an additional hidden 11 characters and 11 stages—one could say that without them, the game is incomplete. Players can additionally collect 293 unlockable trophies, but they

serve little to no purpose in relation to competitive gameplay.

Competitive *SSBM* is always played one-on-one (singles) or two-on-two (doubles/teams), a similar player/team distribution to tennis, and uses very few of the features that differentiated *SSBM* from other iterations of the *Smash* series. This implicit rejection of Nintendo's addition of more casual, collectable, and fun elements reveals community ideology.

Adversarial Esports Shaped by its Players

Through examining how *SSBM* is played competitively today, we can better comprehend the intersections between materiality, embodiment, tinkering, and esports. Playing *SSBM* competitively mandates the use of three essential hardware objects: the cathode-ray tube (CRT) television, the GameCube (alternatively, a Nintendo Wii that has been modified at the software level, or *softmodded*), and the GameCube controller (GCC). Players' strict adherence to these three central hardware objects has led to the development of specific tinkering and *modding* practices. *SSBM*'s use of hardware that is now considered outdated by modern video gaming and esports standards speaks to a reactivation and transformation of residual media. Media scholar Charles Acland notes that the existence of the Internet plays a crucial role in a networked community like *SSBM*, as it causes new media to enclose the old because of its age. *SSBM* is a particularly interesting case of this phenomenon, as new media (e.g., internet) simultaneously enables the community to thrive and enables the longevity of existing competitive hardware standards revolving around old media (Acland 3-5). These tools take on an important role, despite most contemporary videogame players' interest in newer, more powerful technologies.

When players choose what game to play, they implicitly agree to

use a specific set of hardware objects, and they abide by tacit community-developed rules for them, which in turn dictate how their body acts during acts of competitive play. As Alex Custodio argues in *Who Are You? Nintendo's Game Boy Advance Platform*, the embodied experience of engaging with gaming hardware is fundamental to the way people actively engage with objects. In the case of *SSBM*, players are expected to acquire, learn, and understand a variety of practices and materials. Engaging in these material practices is a means of joining the community of competitive play, which maintains its longevity through the reuse and adaptation of residual hardware. These practices are inextricable from community capital, and participating in them cements peoples' identities as *SSBM* players.

SSBM is the one of few games played competitively at a professional level where the developers no longer regularly change, alter, or patch the original software. This lack of change and how it has denied *SSBM* players access to privileges competitors in other esports have has afforded players a unique corporeal experience; one such privilege is the ability to converse with the developers about the development of the game's meta—the most dominant or widespread approach to a game at a given point of time. Esports scholar TL Taylor, whose bibliography is pivotal to understanding esports studies and will be cited and further discussed later on in this book, explains the relationship of material esports to bodies in terms of "the ways the corporal body plays an active role in skilled performance and the assemblage of that skill and expertise as produced

III. Hardware & Software 31

through a network of bodies and technology" (*Raising the Stakes* 37).

The timeline of signal processing is significant to forming an understanding of *SSBM*, because *SSBM*'s release in 2001 rests in the middle of the timeline. Most other esports rely on digital signal processing, so understanding the "forgotten" signal processing history is crucial for seeing the lengths that *SSBM* players traverse to play.

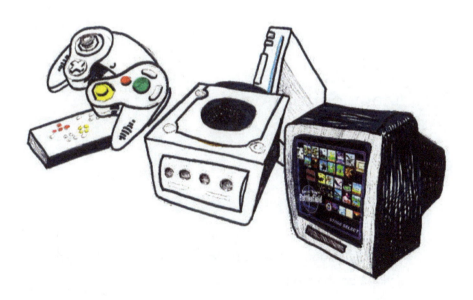

The Holy 3. Ink on paper (2019).

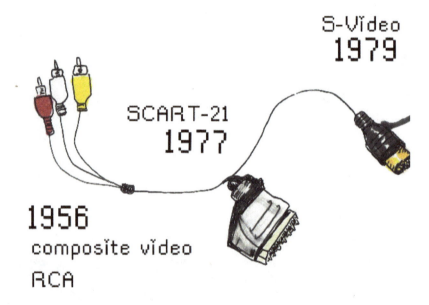

These illustrations show the materiality of *SSBM* as well as the history of video connections that preceded it.

III. Hardware & Software

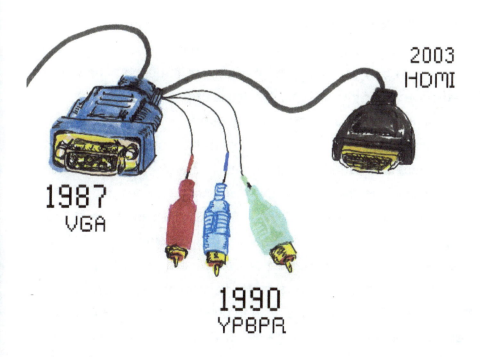

What Lag is for *SSBM*: The CRT Debate

The CRT television is arguably the heart of the competitive *SSBM* experience. It is one of the most essential pieces of hardware required to play the game, its constant use throughout the roughly two decades of this community's lifespan promotes and maintains a community-wide standard for play, and it is undoubtedly one of the most visually and audibly recognizable physical indicators of the competitive *SSBM* experience to many community members. CRT televisions are built to display high-contrast video and can only receive analog signals. Because *SSBM* was released before liquid crystal display (LCD) televisions became popularized in domestic spaces—which only happened around 2007 according to Beach—and the Nintendo GameCube, much like most other gaming consoles in the early 2000s, was designed to output analog signals, *SSBM*'s earliest players played the game on CRT televisions. Even when LCD televisions were introduced to the market, refused to switch from what they knew. The case for sticking to CRT televisions wasn't just a matter of competitors wanting to stick to familiar hardware for the sake of consistency, however; their primary appeal to competitors derived from their 60 fps (frames per second) frame rate and what was, relative to LCD televisions, a very short amount of lag.

So what are we talking about when we discuss lag? Lag is the time

III. Hardware & Software

between a player's input on a controller and when the corresponding in-game action occurs on the screen. Competitive *SSBM* players are unusually and remarkably sensitive to lag, as their in-game movements have small margins for error. Certain techniques require frame-sensitive button inputs; a single frame can be the deciding factor between triumph or defeat. Studies conducted by contributors to popular community blog Melee It On Me show that LCD televisions can add anywhere from 42 to 151 milliseconds of lag, and can also cause a button input lag of 2 to 9 frames (Laferriere). This difference is pivotal for players, as some attacks can make contact or expose their hitbox for only one frame.

While the CRT has established itself as the optimal display for *SSBM*, since the inception of the game's community, it has fallen out of favor with the rest of the world. CRT televisions haven't been in production since 2008, and as a result, they've become increasingly difficult to acquire and maintain (C. Smith). Consequently, players have begun to develop different additions or dongles to add to an LCD *setup* to cut down the input lag, attempting to recreate the feel of playing on a CRT, such as EON's collaboration with Dan "Citrus300psi" Kunz, the EON GCHD Mk-II. This adapter replaces the composite cables with standard HDMI-out in order to deliver native 480p. The process of creating additions and dongles to mimic the experience of the CRT happens because the entire competitive *SSBM* experience revolves around this zealous adherence to residual media. This deep obsession with maintaining a consistent

standard throughout the nearly two decades of competitive play distinguishes *SSBM* from almost every other esport, for, instead of readily adopting new technologies as they come, *SSBM* players instead focus on modifying and finding alternate uses for those new technologies to emulate residual hardware. Preserving the aspects of the CRT considered "best" or most optimal for competitive *SSBM* play overrides the expectation to grow and change parallel to technological advancement—to move forward in *SSBM* is, in a way, to move backwards.

2 Consoles, 1 Experience

Ever since Nintendo stopped manufacturing the GameCube, let alone new copies of *SSBM*, finding the console and a copy of the game on a GameCube disc has become a difficult and expensive endeavor; the game alone typically runs for around $80 USD on eBay. The Nintendo Wii provides a discounted solution—provided players are willing to use a ROM copied from a legally purchased disc—without sacrificing the 480p progressive scan that *SSBM* requires. However, in the case of *SSBM*, the legality of creating backups of the game for personal use hasn't actually been litigated.

The Wii's ability to run GameCube discs natively and its inclusion of four GameCube controller ports, coupled with two USB-ports, a slot for GameCube memory cards, and one for SD cards heralded an opportunity for programmers. As *SSBM*'s popularity ascended, the demand for the game grew too much for many stubborn players to commit to paying for a copy of the game. Many players would agree that the demand for *SSBM* has well outgrown the supply. Thankfully, running *SSBM*'s software on a Wii by using a modified SD card runs at the same frame rate as a GameCube copy, as long as players are using a CRT display. Thus, *SSBM* players began to develop, share and circulate information on software *mods* to ensure quicker access to the game.

The tools for and guides to various specific Wii-*modding* practices (e.g., SD card formatting, emulation softwares, how and where to download various training packs for *SSBM* like *20XX* or *Uncle Punch*) are readily available online and require little to no prior knowledge of programming to understand and execute. As a result, *SSBM* players have come to value the GameCube and Wii equally in terms of their potential for use in competitive play, for it is general knowledge in the *SSBM* community that the two consoles produce the same authentic hardware experience. This is yet another community standard that sets *SSBM* apart from other esports and video game communities, many of which are plagued by the ongoing debate between PC and console users as to which platform is "better" or more "correct" for play.

Adherence and Love for the CRT

SSBM events, from a *Smash fest*—a gathering of *Smash* enthusiasts to play, talk and breathe *SSBM* —in someone's basement to national tournaments, confirm the CRT as eternal. Acquiring a CRT is a fundamental part of the *SSBM* player experience. The search spans thrift shops, parents' basements, and online shopping markets.

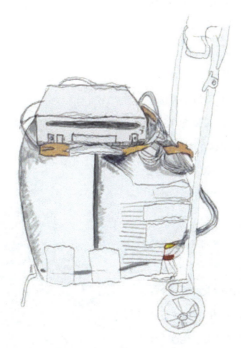

S-Royal's "Melee Machine". Ink on paper (2019).

The search for the correct hardware can be difficult but also enticing in its challenges; the harder the objects are to find, the more players want them. Many *SSBM* players also see the ritual of finding the right hardware as a rite of passage. Players unite over pictures of broken CRTs on the side of a road through circulation on social media. Some players keep a small CRT in the trunk of their car, not knowing when they might need it. Players board international flights, clenching their CRT on their lap to ensure they have a *setup* in their hotel room at an event. *Setup* here refers to a CRT, gaming system (Wii or GameCube) with AV cables and power (i.e., everything one needs to play, barring controllers). Bringing one's own *setup* to an event is essential, because it is a rarity to be able to play casually in the venue, as the *setups* are needed for competitive matches. As well,

III. Hardware & Software

bringing one's own *setup* is a way of showing what one represents. It is a badge of honour for many to supply a working *setup* of their own at an event where none are available. On a broader scale, gaming event companies collect and store a number of these chunky televisions to supply to events in an attempt to standardize—and monetize the rentals of—competition hardware. Players create alternative *setups* like Takuto "S-Royal" Maeuchi's Melee Machine made for playing *SSBM* anywhere, anytime. The spectacle of a large-scale tournament is as much about the image of bright, coarse televisions and the sounds of their high-pitched rings as it is about play itself. The adherence to the CRT television is strict, but the standard exists out of a nostalgic fondness for the game's beginnings.

spoopy with abadoned CRTs (2016-2020).

Reframing the Debate: A Software Issue

As previously stated, playing *SSBM* on anything but a CRT television causes a significant delay between input and action on screen. While many players frame this issue as being rooted in signal processing, one player directed attention to a different source of the issue. Instead of framing lag as a problem with LCD televisions, Aziz "Hax$" Al-Yami redirected players' attention to a different source of lag: a supposed issue within the *SSBM*'s software code. Hax$ enlisted the help of signal processing guru, David "Kadano" Schmid, who used an oscilloscope to test lag on a variety of displays. Dissatisfied with the results of previous tests performed with what they believed to be highly subjective variables, Hax$ and Kadano dove into the game's software code themselves. They found that, although the GameCube runs at 59.94 Hz, *SSBM*'s code runs at 60 Hz.

This discrepancy causes a *desync*hronization (commonly abbreviated as *desync*) between the console and the game engine (Al-Yami). *Modders* such as Achilles, Dan Salvato, and tauKhan have rewritten some of the game's code to "fix" this *desync*, which Hax$ identifies as a "mistake", even though other players might not see it as a problem. Hax$'s approach, as will be described later on, and the *softmod*—short for *software modification*—that resulted from it, are both in their infancy and haven't been adopted universally by

the community at large.

These players' pursuit of lagless play exemplifies the process by which opinions of individual community members become incorporated into community discourse and debate. I clarify that these are opinions, because perception of lag and latency can often differ from individual to individual; all sorts of external factors can impact one's ability to perceive or experience lag. Despite this, discussions of lag have fueled already notoriously vitriolic community debate for the past several years. While the competitive *SSBM* community is undoubtedly fortified by the love and passion for the game that its community members maintain, that love and passion can often induce an emotional perception of reality that obscures what reality actually is—a phenomenon that can be observed in many different instances of debate within the *SSBM* community, not just this one.

Embodied Play: Adapting Body to Hardware

Given the variety of hardware needed for competitive play, players adjust their body in line with the tools in use. The body's most prominent tactile connection to the game is through one's own controller. The traditional, most common method of holding a controller is as follows: the controller rests in the player's palms, and one thumb is placed on each side of the controller grips. Some players, including myself, hold the controller the way one grips a fight stick pad, with their index fingers, rather than their thumbs, on top of the buttons—this is known as *claw* or *half-claw* grip. It may look awkward, but for players who specialize in, or main, certain characters, this grip allows them to input specific button combinations more quickly than they would be able to with a traditional grip. For example, many players who *main* Princess Peach learn this grip. Peach's most unique function is her ability to float, which requires the player to press and hold the jump button (either X or Y). Playing *claw* or *half-claw* allows players to rest multiple fingers not only on the jump (float) button, but also on other buttons. This stance allows Peach players to float while simultaneously putting out aerial attacks with the A button and/or C-stick.

 Some players don't even play with their hands, often due to reasons of preference, accessibility, and/or chronic pain. One player, Char "Charmizelle" Elizabeth Mizelle, plays with her feet, while one

of the most well-known players from Japan, Daiki "Rudolph" Ideoka, arranges three chairs in a row to play lying down on his stomach, simply because he favours this position. These are both examples of players who have adjusted their bodies to suit their best self-optimized playstyle, ability and performance.

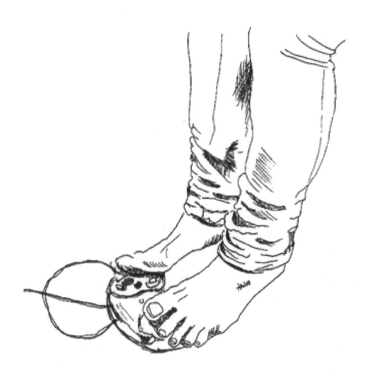

Char's "foot Puff". Ink on paper (2019).

Snapback and UCF

Not every controller is perfect. Ample documentation exists online addressing how to test one's controller for many of the potential physical defects or issues a controller can have; one of the more common issues pertains to a controller's *snapback*. A controller's *snapback* is indirectly linked to its *dashback*, a software phenomenon. A controller with a loose joystick occasionally registers incorrect inputs—not mistakes made by the player, but actions that were never inputted by the player at all. The potential for incorrect inputs, notably a hardware issue, is pertinent to a software phenomenon known as *dashback*. As described by community figure and controller *modder* Mike "Typo" Bassett in an article for Melee It On Me, *dashback* is where, in the "first frame of pushing backward, the game registers a half press, [so the player] will get stuck in the turn animation for 5-9 frames (depending on character) before [they] can start [their] backward dash". Understanding this link between hardware and software is important, because whether or not a controller is deemed to have "bad" or "poor" *snapback* determines whether a controller is viable for competitive play at the top level. Less than 40% of controllers are perceived to be "top tier"; consequently, the rest are deemed unfit for competition (Bassett).

Subsequently, independent game developer Dan Salvato (Twitter:

@dansalvato) and several others developed a *softmod* designed to fix, standardize, and regulate *dashback*, as well as other common issues with mechanics such as shield rolls and shield drops, for *SSBM* (Twitter: @UCF_SSBM). It's referred to as a "universal controller fix" or UCF (consoles or game discs with this modification applied are referred to as "having UCF"), and it levels and renders controller equality. UCF enables *SSBM* players to feel as though they have a higher-tier controller by addressing the discrepancies between models. UCF addresses the (in)availability of controllers and levels the playing field (Salvato). There is a commonly held belief among *SSBM* players that there are "good" and "bad" controllers; UCF inherently defines what a "good" controller looks through the lens of UCF's *modding*. There has been some *softmodding* done to help players test controllers, but it's frankly just about impossible to tell how "competitively viable" a controller is from looks alone unless it has glaring visual or physical deficiencies.

Downloading and sharing UCF with a USB is simple, as it runs when inserted into a *softmodded* Wii. To make running UCF even easier, individuals started producing GameCube memory cards on their own that came with UCF already attached to the game's software. After Nintendo employees heard about this, they told competitive *SSBM* players they were not allowed to add UCF to the game's software, especially in a competitive setting; Nintendo viewed UCF as a modification that enabled an "unfair advantage"— although it's unclear to whom exactly this advan*tage* was granted

through UCF from Nintendo's perspective—and fostered a form of competitive play they refused to acknowledge (I. Khan).

In response to the legal threats issued to tournament organizers by Nintendo, players developed a hardware *mod* using a single-board microcontroller manufactured by open-source electronics platform Arduino that is inserted into all four GameCube controller ports, which adds UCF to gameplay directly through the controller's connection. Somewhat confusingly, both the microcontroller itself and this particular external hardware *mod*, which is small enough to even solder directly onto the electronics inside controllers themselves, are both referred to by the competitive *Smash* community as *arduinos*, and even more colloquially as *dweens*. Some larger tournaments have used this external hardware mod on all *setups* in their venues, but others have continued to use the *softmodded* GameCube memory cards without publicly disclosing it.

Before the potential of Arduino microprocessors to safely modify and standardize the competitive *Smash* experience was ever widespread public knowledge, some players who were ahead of the curve were indeed soldering the Arduino microprocessors onto the electronics of their controllers to achieve frame-perfect inputs. This practice immediately incited controversy; Arduino-*modded* controllers and other forms of tool-assisted techniques are illegal according to the rules of most tournaments, yet there are little to no ways of enforcing these rules that don't involve asking players right out to unscrew and open their controllers. Adding an Arduino microproces-

sor to a controller is one of the few forms of cheating that players can get away with at tournaments, given how difficult it is to detect.

III. Hardware & Software

Here are two shell backs of a GameCube controller. The black/first one includes the spring resistance built into the triggers; the second/purple shell has had its springs removed. This is a common hardware *mod* for *SSBM*. This image shows the slight height difference between controller triggers that this produces. The triggers are crucial buttons as they are the main shield option, can be half-pressed to make a less substantial but still potentially useful shield and are used to *wavedash* or *waveland*, which will be expanded on further in the technique section of the book. Many players prefer to only *mod* one side of their controller, as they only use one trigger button and they both do the same inputs. This *mod* also relieves the player of the "half-press" on the trigger, making it easier to have a confirmed button input each time. However, removing the spring means sacrificing the light shield. A *mod* like this will almost always be done because of a player's subjective perception of their controller's *feel*.

Controllers, But Make it Fashion!

In addition to modifying controllers for performance, many *modders* also alter their controllers to better suit their personal aesthetics or sense of style. Controller *mods* may include the use of custom shells, buttons, and wires, as well as other miscellaneous additions of purely decorative or aesthetic value. Having a unique or stylized controller is common amongst competitive *SSBM* players and is one of the ways that players express their passion and dedication not only to their personal hardware but also to their personalized experiences of *SSBM*. The aesthetics of the controller often signify the player's alignment in a given community or fandom or reveals parts of their identity to which they wish to draw attention. The controller is the player's direct and explicit connection to the game. In discussing materiality, Matthew Kirschenbaum (10-11) states that "materiality rests upon the principle of individualization." He explains that no two physical objects are the same by nature of the way that our bodies experience them. Two players might be given the same controller, but their feelings and experiences of that controller, or of any hardware for that matter, are ultimately derived from on their individuality and their bodies.

Frankenstein Controller: Artist's Statement

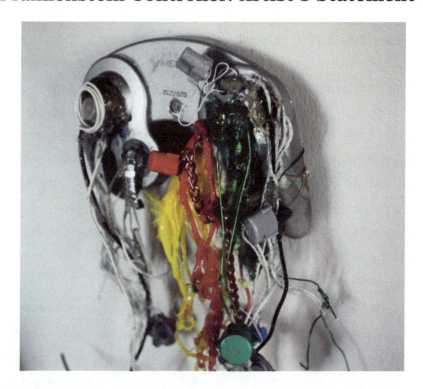

Here is the Frankenstein controller, circa 2019. It is made from the top shell of a GameCube controller. The control stick gate of this controller was unevenly notched in an attempt to make a game mechanic known as *shield-dropping* easier for the player gone wrong, rendering it useless to a competitive *SSBM* player. In the earliest days of controller *mods*, many referred to their controller *modding* practices as "Frankensteining" their controller, for the earliest controller *mods* were unorthodox experiments that often left players with

hideous results; there was very little in the way of universalized practice. Players may spend large sums of money or hire others to create their "ideal" controller. *SSBM* players—myself included—often own several controllers at a time, as the search for perfection or optimization inherent in *SSBM* culture entails testing and *modding* multiple controllers in order to find the right fit. As players optimize their controllers, so they optimize their bodies in tandem through changing their grip, the speed or pressure with which they push buttons, and so on and so forth; the controller and the body are both being worked to become great. Most controller projects end up reflecting the themes of the Frankenstein story: the pursuit of (dangerous) knowledge and sublime nature through the mixing of human and machine (the non-human).

SSBM players are constantly seeking means through which to optimize their play and push the limits of their hardware, but the process of *modding* their controller to achieve this can be dangerous; it often involves sharp tools and soldering irons. It is relatively easy to ruin a controller in the process, which can place a financial burden on the *modder*, given how expensive the controllers have become (a brand-new un*modded* controller on Amazon costs around $150 USD+). Each *modded* controller offers a subjective experience that may allow a player to rejuvenate their play. Often, when players are stuck in a rut, they turn to incorporating additional hardware or other controller *mods*: getting tune-ups from other *modders*, switching out their controller casing, replacing buttons, even purely aesthetic

changes—akin to trying on a new outfit to boost one's confidence. Sometimes, a newly *modded* controller can play a significant role in a player's success—but often this newfound success leaves a trail of monstrosities such as the one pictured below in its wake.

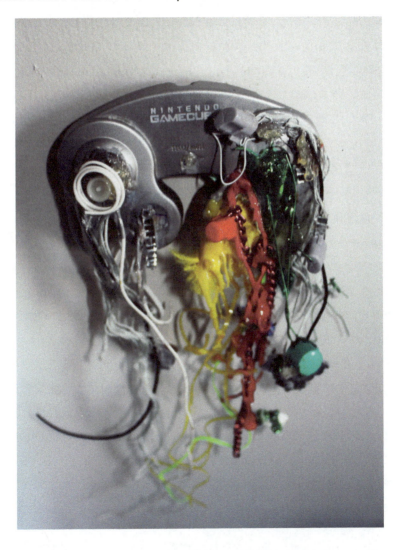

IV. Discourse

Where and How Discourse Forms

Discourse is the language and attitudes used to convey knowledge of and alignment with the game and community. It creates context, determining what it is possible to say—or not say—about a particular subject in a given time and place. Michel Foucault's approach to discourse analysis emphasizes power relations. What a community adds to the discourse—as well as what they omit—governs and determines what is "good" or "bad", "allowed" or "not" for the social body of the *SSBM* community (*Archaeology of Knowledge*).

In addition, building on Foucault's discourse analysis, Janice Radway's notions of interpretive community shows a strong correlation between the formulation of meanings and the individual's situation. This is to say that opinions and ideas in a given community are not immune to the influence of a person's background or personal experiences. Radway's analysis centralizes romance readers as her subject, but the same framework can be applied to study *SSBM* as a group with a centralized passion, focus and topic of interest. Primarily, Radway looks at the interactions and relationships between readers and texts. Here, the interpretive community I study is that of competitive *SSBM* players, a relationship between serious or competitive player and game. Both the readers Radway describes and *SSBM* players "conceive of 'production' or 'construction' as opposed to…

consumption" (52-54). This excerpt shows reading as an engaging production activity, where knowledge and ideas are actively being created in use. Involving oneself in *SSBM* is an ever-changing process for each player, because personal moral or ethical codes and cultural contexts indefinitely effect interpretation. Applying this understanding of the modes of cultural formulation to *SSBM* indicates the foundations of *SSBM* culture as inextricably connected to the identities, backgrounds, values and principles of its players. I draw on Foucault's stress on power relations in discourse with Radway's method of analysis that emphasizes the "reading" (gaming) process as a site of production, because it discusses the importance of social and material situation to interpretive communities.

It is crucial to note that interpretive communities, while they may share the same fundamental base, often include a variety of opinions. The metaphors described by Radway can be interpreted as analogous to the tools of *SSBM* and the purpose of playing, for Radway states that "interpretive communities may not simply differ over what to do with metaphors... they may disagree even more fundamentally over the nature and purpose of reading itself" (53). Nintendo's design philosophy of recycling intellectual property is the foundation. Anything else is community and interpretation. However, while an individual player's relationship to the game can be instructive about community values and ideology, it lacks the depth and nuance that a study of community culture and online participation can generate.

Radway's work calls for ethnographic studies of different kinds of behavior, attempting to think about how people operate, use and circulate around printed matter. Radway asserts that the meaning of a text is a result of complex and temporally evolving structures and interactions between a fixed text and a socially situated reader (54-55). This is to say that game developers' and Nintendo's reluctancy to update or change *SSBM*, coupled with the player in contemporary (Western) society creates a subversive discourse, dominated by *SSBM* players. It is important, as Radway suggests, not to focus solely on the player's relationship with the game, since doing so risks overlooking key desires and challenges (56).

To that end, I leverage Mizuko Ito's work on participatory culture and individualization in networked communities. Ito writes that "by examining participation we see our relationship to 'content'... as a part of shared practice and cultural belonging, not a process of individual 'internalization'" (Jenkins et al.). *SSBM* players' identities and careers are fundamentally shaped by their active participation in the community's network. The *grassroots* nature of *SSBM* influences the feeling of a shared practice because its members have built and determined its network.

When players participate in and internalize the discourse surrounding *SSBM*, it influences their vernacular and positions them as subjects of the game. Moreover, discourse can function as a mechanism of regulation. *SSBM* players have created a lexicon that expresses communal or differing opinions on the same fundamental

hardware and software origins. The lexicon reveals patterns in identity performance that players enact in order to achieve this positioning. The words and phrases I chose to discuss in this book highlight etiquette and community norms; they show that the entire basis of what is "good" is specific to the competitive *SSBM* community, and can likely be investigated as representations of *SSBM* sub-community values so as to uncover what different regions expect and honour in terms of both gameplay and ideology.

Broken & Balanced

One popular example of competitive *SSBM* vernacular that has existed in the community for a long time is the term *broken*. To call a character, move, interaction, or instance *broken* is to call it overpowered, or "too good." This isn't always a term of negative connotation, however, for it's also a term that belies promise: for example, characters deemed *broken* are strong—and perhaps exciting. However, players are also interested in the discourse of balanced play, which is made evident through the existence of community add-ons like UCF, which doesn't balance gameplay but rather levels controller discrepancies.

IV. Discourse

A drawing of a move shared by playable characters Fox McCloud and Falco Lombardi called the *shine*, a move often deemed *broken* both by people in and on the peripheral of the *SSBM* community. Coloured pencil and ink drawing originally commissioned by Slox (2017).

Discourse for Gameplay

While the discourse concerning what is *broken* and what is "balanced" reveals power dynamics at play in the competitive *SSBM* scene, other crucial phrasings relate more directly to gameplay. As players improve their technical skills, their mindset and their gameplay become more central to the competitive experience.

SSBM discourse describes playstyles as either aggressive or *campy*. When players throw out as many hitboxes as possible and approach their opponent frequently—this is referred to as rushing down one's opponent—their play is deemed "aggressive." Slower and patient play, on the other hand, is known as *campy*. *Campy* play is characterized by reluctance to approach one's opponent, as if they were setting up camp at the opposite end of the stage; instead, the player waits for their rival to make a mistake or otherwise present them with an opportunity to exploit a weakness—an opening. This strategy is extremely successful, as it has kept player Juan "Hungrybox" DeBiedma the title of the best *SSBM* player in the world for three consecutive years. However, many *SSBM* players see *campy* play as "lame" or "uncool", which implies the game is meant to be watched.

In an article debriefing a tournament from 2019 where a player quit because their opponent *camped* throughout the entire match,

reporter Ian Walker writes,

> playing to the growing spectator class is sometimes considered more important than allowing competitors to use whatever tactics they need to ensure a win, even if those tactics aren't that exciting to watch. (Walker)

Regardless of whether a player's approach to the game is deemed aggressive or *campy*, there is always a winner and a loser. Other players of fighting games at a competitive level often regard *SSBM* players as notoriously passionate about arguing about what's *broken*, balanced, banned, not banned, cool, or lame. Serious and/or *salty*—remorseful, agitated, upset—players are known for coming up with a long litany of excuses when they lose. Popularized especially through its appearance in *The Smash Brothers,* excuses for losing have been termed *johns* (Beauchamp). Some *johns* have achieved almost universal recognition among Smash players. Common *johns* include controller issues; not enough sleep, food, or water; a cold venue; or a lack of time or resources given to "warm up" before a game or set.

The typical response to someone *johning* is to say "no *johns*"— there should be no excuses for losing. This term, though incredibly common amongst *SSBM* players, can come off as patronizing, harmful, and ableist, especially when directed towards new players. It evokes the same sentiment as "toughen up" and other phrases with strong ties to sexist narratives of masculinity as a tough, unyielding ideal; the underlying ideology evident in using turns of phrase like

"no *johns*" is that all *SSBM* players should seek to live up to this ideal. Getting upset even in the most frustrating of circumstances is looked down upon, because all legitimate complaints about one's loss are inherently grouped in with complaints deemed dishonest, weak, or otherwise illegitimate by the community.

Development of Universal Rules

In the early days, within about ten years of the game's release, certain regions within the global competitive *SSBM* scene opposed the exclusion of all items that randomly appear during gameplay, given that several characters in the game's roster had innate projectiles with similar properties. However, over time, this resistance has since faded into extinction. Turning all items off has become a practically non-negotiable requirement for all forms of competitive *SSBM* play, whether in tournament or during casual matches between competitive *SSBM* players (*friendlies*).

This is one of many examples of an individual rule that has been universally adopted by the competitive *SSBM* scene at a global level. In addition, it exemplifies how "rules are not fixed, [for they] are evolutionary systems that grow alongside the ongoing construction and performance of play," as concluded by T.L. Taylor (*Raising the Stakes* 55). Rulesets have been posted and shared online on the Smashboards forums as early as 2009 (Skler), as well as on the official websites of major tournaments in competitive *SSBM* history such as EVO 2015 and the Apex series, as is documented on SmashWiki ("Super Smash Bros. Melee in competitive play")—over time, the slight differences between these rulesets were examined and discussed by the community at large, and many of these differ-

ences have shifted in nature if not outright disappeared.

For example, it is now commonly expected in competitive play that each player is assigned four *stocks*, and that the in-game timer is set to display an eight-minute countdown—after which the match is over, even if neither player's *stocks* are depleted. Most matches end before all eight minutes have passed; audiences tend to find matches boring or slow when they run out the timer's entire duration. The fast gameplay is a result of *SSBM* competitive culture's expectation for innately fast pace play. The players themselves reinforce this expectation by loving to play the game quickly, coupled with the existence—and unending documentation online—of matches or sets played at an electrifying pace, making any other form of play seem boring in comparison!

Most tournament rulesets also insist on only five of the game's twenty-nine stages being tournament "legal". These are perceived to be the most "neutral" stages in that they're, generally speaking, flat, with up to three platforms that only sometimes move, presenting few non-player-induced hazards during the battle. There are minimal differences between these five stages, which arguably standardizes the landscape on which the game is played. To that end, the ruleset also bans items in competitive play. Ultimately, competition brackets are typically double-elimination, which gives players at least two chances to advance.

This ruleset has solidified over time and is now expected in almost all forms of play for *SSBM* players. Only recently have additional

side-events boasting non-standard rulesets been hosted at tournaments—examples of these include Rishi's Jungle Jam, which was first held as a side-event at Shine 2018, and Sami Singles, first introduced at Smash Summit 9. More often than not, alternative formats such as these present opportunities for more light-hearted play. However, Sami Singles, due to its severely condensed game timer of one minute, also inherently forced players to approach more often as opposed to playing *campy* or "defensively." The limitations it imposed on players were intended to challenge players to imagine and create new standards for play. Of course, not everyone who participated took it so seriously, but this goes to show how the imaginative exercises that alternative formats present hold competitive value and can teach us about new ways to conceptualize, think about, and further the game in addition to having potential for fun.

Power & Responsibility

The community-wide discourse surrounding balanced and *broken* gameplay intersects with the conversation around what is or is not banned. Many rules and parameters are universally accepted as standard at this point in *SSBM*'s history (see Development of Universal Rules). However, there are a few conditions or situations that are sometimes left up to the discretion of the tournament organizer (TO); for example, in recent years, whether or not to ban a technique known as *wobbling* (see Case Study: *Wobbling*) has been a source of heated debate, and TOs across the globe remain divided on whether or not to allow it at their tournaments. The TOs are one of the more obvious sources of power at play in the competitive *SSBM* community due to the executive nature of their responsibilities: they are the ones who run brackets, instate rulesets, communicate with the venue, and juggle players' questions and requests. Occasionally, especially at bigger tournaments, a whole team of people takes on this role.

Other teams, such as community hub website Melee It On Me (MIOM) and the recently formed SSB Code of Conduct Panel (colloquially referred to as the CoC) also contribute to the discourse by describing what is and is not allowed in regards to behavior and social conduct. Instances where bans issued by the CoC are ignored by

TOs, especially when the ban concerns a player's toxic or otherwise harmful behavior, are deviant and disappointing; more often than not, bans exist for the community's safety. When a "banned" player is given permission, whether directly or indirectly, by the TO of an event to compete or participate, this can undermine the power and influence of the CoC's decisions.

The establishment of the CoC marked the first time that a universalized standard for player conduct had ever been attempted within the competitive *SSBM* scene. Its conception grew out of a shared awareness that bans were difficult to enforce without some wider standard of accountability in the community at large; without all TOs united into pressuring each other into upholding those bans, because of the *SSBM* community's lack of central authority, bans can be hard to enforce. Nintendo does not oversee tournaments in any official capacity beyond offering "sponsorship", in contrast to how most developers interact with and support their esports (e.g. Blizzard's *Overwatch*). Even at tournaments hosted at privately-owned venues with their own rules and, occasionally, hired security, attendees often tend to play by their own rules—for example, sneaking alcohol into venues is a common practice at *majors* especially (see Case Study: Drinking Culture). Due to the large scale of tournaments, the lack of oversight on Nintendo's part, and the relative novelty of the CoC, regulating behaviour at events has proved a difficult endeavor.

Discourse Formation by Authority Performance

To trace the formation of group standards and authority, Carolyn Marvin's study of the rise of the electrician in the early twentieth century is a useful case study for understanding how experts emerge in a given community. In the context of electricity, the idea of an expert arose through the pursuit of universalized "proper" standards for repair, discussion, circulation of knowledge and discourse. Electricians created journals and shared texts that positioned themselves to the public as experts of their emerging field of study. Marvin explains that the notion of the expert arose as a new form of accreditation developed by the textual community—that is to say, through written documentation of knowledge—independently of professional guilds or the academy. Experts discursively position themselves as such, highlighting the ways in which power is always at play in expert communities; after all, in order for experts to exist, there must also exist a "public" or category of people with lesser knowledge of their chosen field of study against whom the experts define themselves. Marvin continues, "those who were socially positioned to know this assumed inventive poses if their skill were not up to par" (17).

SSBM players who define themselves as experts do so through participating in online forums, as well as writing or otherwise interacting with gameplay guides; examples of this behavior can be found

on Smashboards, the "SSBM Tutorials" YouTube channel, Reddit threads including those found in subreddits such as r/SSBM and r/smashbros, MeleeLibrary.com, and the online circulation of player testimonials or anecdotes.

SSBM experts unite through their own manifestation of technological literacy. Often, both those unfamiliar with or on the peripheral of the competitive *SSBM* scene, as well as those within the scene, frame technological literacy as it pertains to the game as a neutral or objective attribute, attained solely through one's skill or talent, as opposed to one acted upon by factors that differ between individuals—the functions of one's mind, body, upbringing, or identity. Similar beliefs have been observed in relation to the history of computing, as described by Marie Hicks: "perhaps the most important fiction in the history of computing is the concept of meritocracy... [or that] technology [acts] as an equalizing force in society" (29).

However, participating in *SSBM*, even online, does not fully erase the impact of one's identity on one's ability to claim success, excellence, or expertise; the microcosm that is the competitive *SSBM* scene is not isolated from the world—if anything, its small scale lends itself to reflecting and magnifying existing issues of identity and oppression. As has been demonstrated through Kishonna L. Gray's research on Black women participating in online gaming forums, gender minorities and/or people of color "take with them aspects of their physical selves and are sometimes punished for not conforming to the white, male default operating within digital technology";

the presence of their "real world identifiers can sometimes lead to oppression and inequality" (63). Hicks, in turn, states that the ideal of the meritocracy cannot be "merely asserted in the face of [these] existing power imbalances" (33). Therefore, it is not sufficient to say that those who claim expertise in *SSBM* through having achieved exceptional technological literacy are able to stake that claim through skill and talent alone, or that the authority of experts is solely cultivated through their in-game performances.

In addition, technological literacy is governed by the body—perceptions of *SSBM* are subjective due to the physical capabilities and limitations of players' bodies as well as their intuitions, shaped by years of cultural and social influences. Truth can be derived from bodies, rather than from texts. Marvin notes that there are constant debates of interpretation of a given text, but rarely about its textual authority, and writes that "disagreements were rarely about the priority of textual authority, or even about broad principles of legitimate interpretation. Their differences concerned substantive points of interpretation..." (14). People who present as experts are able to assign names, labels, and signs to things which in turn can and do become part of community discourse.

In order to discuss the way players perform their expertise in the *SSBM* community, I again point to the example Hax$ poses, and how he presented to the greater *SSBM* community software modifications designed to fix what he perceived to be mistakes in the game's programming. In his 20-minute video (Al-Yami), he presents data and

IV. Discourse

charts against a black background. The connotations of this presentation style aid Hax$ in positioning himself as an expert. He combines academic visuals with a documentary-style voiceover; he fills the video with technical jargon and numerical data presented visually, and this, combined with the obsession with playing "optimally" tied very closely to his public persona, assists him in making his claim to being an "objective" authority on *SSBM*.

Hax$ begins his argument with the claim that *SSBM* players need to change the existent hardware standard, for CRT televisions are becoming increasingly difficult to find, let alone store, yet the use of monitors and LCD televisions still receives backlash from the community as they add input lag to gameplay. Hax$ claims that this seemingly unsolvable issue has been left alone by TOs. Hax$ presents his solution to this problem as the only way that competitive *SSBM* can flourish in the future.

After that, the video is quick to dive into presenting technical and numerical data. Hax$'s argument for how to "solve" the future of competitive *SSBM* centralizes the use of an HDMI adapter, and he cites Kadano's previous research so as to demonstrate how using this adapter adds insignificant and unnoticeable lag. Then, he quickly switches topics in order to discuss the differences between how CRT and LCD screens display and capture video. In conclusion, the video notes that while scanlines are present on both types of displays, those rendering images on CRTs have no transition between frame (binary), while LCDs may add a transition or overlap of two frames

as they switch from one to the next (non-binary). Hax$ features more of Kadano's research at this point, showcasing the data Kadano collected through testing the input lag and the latency of the popular BenQ RL2455HM monitor. Hax$ does note in text that some of the measurements featured in his presentation are "subjective measurement[s]" and "not thoroughly tested", but nevertheless the visuals and aesthetics of this presentation cement this research as objective. Hax$ notes as well that the eyes of players and reactions times in game will range from player to player. Hax$ clearly notes that there will always be a subjectivity in how laggy one may perceive an LCD to actually be. Despite this assertation that the perception of lag can be a subjective matter as opposed to an objective one, the video continues to discuss the ways latency has been added, removed, and leveled for existent community-built modifications to *netplay* such as Faster Melee, then the predominant modification to Dolphin before the community-wide adoption of Project Slippi's modification.

Then, Hax$ dives into analyzing the game's code and identifies what he deems to be an "error" in the game's code; he refers to this as *polling drift*. *Polling drift* causes latency to fluctuate between a half a frame and one frame of delay. Hax$ states he would like to see *polling drift* "fixed", even on *setups* with CRT televisions should the adaptation of the game to LCD monitors not come to fruition, because apparently his proposed "fix" has already been discreetly applied to Faster Melee, unbeknownst to most players.

At the end, Hax$ presents his conclusion with regards to the

"future of LCD Melee", showing a list of how many milliseconds could be saved if people were to employ a series of fixes—including his own *polling drift* fix and some visual buffers. Nevertheless, he demonstrates clearly that the efficacy and impact of more than half of his millisecond-saving findings have not been thoroughly tested. That said, Hax$ provides his code in the description allowing players to test it if they so please, using essentially the same equipment needed for the most common Wii-based *setup* used by most of the competitive *SSBM* player base.

The video seems to care more about getting people to test Hax$'s code more than trying to solve the larger issue of CRT televisions becoming increasingly difficult to find, much less move or store. Hax$ uses this sleek academic or lecture-style presentation and the presence of numerical data to lend power and authority to his argument in hopes of, ultimately, influencing community discourse, regardless of how accessible or truly effective the solution may be. There exist many videos like Hax$'s online that try to argue how competitive *SSBM* should or shouldn't be. It is important to question sources like these and interrogate forms of power in a community with no official governance.

Timelining History & Discourse

Players and community participants shape discourse within specific contexts and times. Many documentarians and community figures have tried to produce a timeline of competitive *SSBM*: Travis "Samox" Beauchamp's 8-part documentary *The Smash Brothers*, Prog and Gangly's docu-series *Last Stock Legends*, Slush's esports and biographical video documentaries, or various mini docu-series released under the brands of successful esports teams like Cloud9 or Team Liquid. The timelines formed in each and every one of these mediums are based on a defined group of players that "matter" and a collective response to shared practices and cultural belonging. The timeline I discuss in this book is one that I compiled based on information I gathered from Samox's documentary, the SmashWiki timeline, and early Smashboards forum entries (Thespymachine).

The history of *SSBM* begins with the game's release in 2001. The earliest era of *SSBM* was shaped by the passion, time, and effort put into studying the game by its devoted player base; the rise of the internet allowed these players to circulate information and build rivalries amongst themselves coupled with a budding competitive spirit. It is around this turning point that most narrativizations of the *SSBM* community's history begin—and it's worth noting here that this self-narrativization qualifies as expert discourse in Marvin's sense,

as the community is legitimizing its own history by assigning mythological status to what outsiders may see as insignificant events.

The addition of the game to the roster of MLG ("Major League Gaming"), one of the largest esports events of the time, arguably signaled the beginning of the game's competitive status. MLG purchased Smash World Forums, now known as Smashboards. While the people at MLG were able to stabilize the forum servers, they also deleted many tournament results and data from years prior ("Major League Gaming"). Many on the peripheral of the community, fixated as they were on the developer's intention for the game to remain casual, called the legitimacy of competitive *SSBM* into question. However, the players remained committed to the community's growth, and they continued to form and circulate their shared ideas about the game's development beyond the space MLG created. This is one of the many reasons that *SSBM* only lasted a few years on their roster, which also included games and franchises that have gone on to see massive commercial or mainstream success—games such as *Call of Duty: Advanced Warfare*, *Dota 2*, and *Smite* ("Events").

As the SmashWiki notes, *SSBM* was removed from the roster in 2007 to make way for the next game in the franchise. Nintendo released *SSBM*'s successor, *Super Smash Bros. Brawl* for the Nintendo Wii, while their antagonism toward *SSBM*'s growth as a competitive game persisted. The community was split over whether to dedicate their time to the newest addition to the *Super Smash Bros.* franchise, or to continue pursuing *SSBM* competitively. *Brawl*

replaced *SSBM* in the MLG lineup in 2010; however, there was soon an incident where *Brawl* players were found guilty of manipulating the bracket. Neither *SSBM* nor *Brawl* returned to the MLG roster in 2012, and their absence from the MLG roster has persisted up to the present day, save for one exception—*SSBM* made one last appearance in the roster of a now infamous MLG event in 2014, but SmashWiki states there were many logistical issues with regards to the organization and recording of the tournament that garnered MLG a lot of criticism. There is little to no trace of *SSBM* on the MLG website today ("Events").

Despite MLG's removal of *SSBM* from their roster and Nintendo's ever-persistent resistance to the budding competitive scene, players remained excited about the game and its competitive potential, leading *SSBM* out of this period of instability and uncertainty—what some players refer to as the game's "dark ages"—and into the widely-acknowledged "Era of the Five Gods." The aforementioned Hungrybox, along with players Adam "Armada" Lindgren, Joseph "Mang0" Marquez, Jason "Mew2King" Zimmerman, and Kevin "PPMD" Nanney, consistently dominated tournaments from around 2008 to 2015. This was an era of *SSBM* defined by the emergence and presence of these expert players. In Carolyn Marvin's discussion of the expert, she states that "experts' own goals were to harness public adulation to improve their own social and professional standing while keeping public admirers at arm's length" (16). The profound technological literacy and mastery of gameplay that set these five

IV. Discourse

so-called "gods" apart from the rest of *SSBM*'s player base allowed them to position themselves as experts. Marvin continues to explain that new media, like *SSBM*, create social groups called audiences—"here," writes Marvin, "the focus of communication is shifted from instrument to the drama [the "gods"] in which existing groups perpetually negotiate power, authority, representation and knowledge" (5). The notion of audience and experts was most apparent at an invitational tournament called Battle of the Five Gods, which solidified this moment in *SSBM*'s history. This era of more advanced *SSBM* gameplay than ever before seen challenged the doubters who questioned whether or not *SSBM* should be considered a *grassroots* project or an esport played at a professional level. Segueing to a more professional presentation and aesthetic for the game was now more of a possibility than ever before, too, as massive companies like Red Bull and esports organizations with reputable *League of Legends* and *Dota 2* teams, like Cloud9, G2 Esports, and Team Liquid, began to develop their stakes in both specific players and the community at large.

This era also heralded the rise of the celebrity within the competitive *SSBM* community. It becomes difficult to separate the notion of expert and celebrity for *SSBM*, especially in the context of *top players*—a common term in the competitive *SSBM* community lexicon for especially skilled, recognized players who maintain both expert and celebrity status. I use the word *celebrity* here, however, because the pressures these *top players* experience to perform

"correctly" both in and out of the game arguably stretches beyond Marvin's original conceptualization of the expert; with the advent of the internet, social media, and other forms of new media has come an audience more ready and willing than ever to publicly respond to your every post, your every move, your every win, your every defeat. This heightened publicity and visibility has inadvertently grabbed the attention of corporate sponsors, who have poured financial support into the competitive *SSBM* scene in areas Nintendo has not and therefore expedited *SSBM*'s growth. For the next few years, the professionalization of *SSBM* would continue to accelerate, as many players, not solely the "gods", were signed to major esports teams, securing their identity as competitors both financially and discursively.

The next era, referred to by the SmashWiki as the "Platinum Age" or that of "The Documentary," took shape from 2013 through 2018. As previously mentioned, the release of documentary *The Smash Brothers* on YouTube brought in a massive influx of new players. This documentary, told from director Samox's perspective, attempted to narrativize the history of the game and its community in order to make the story of *SSBM* more attractive and accessible to *gamers* at large. This completely new demographic are often somewhat derisively referred to as *doc kids* because the only became interested in *SSBM* after watching the documentary. SmashWiki notes a Tafokints tweet that reads: "[*doc kids*] basically represent people who got into the game after Aug [sic] 2013 in light of the Smash Documentary" (D.

Lee). The pejorative use of the term stems from the belief that these players not having been present for the initial *grassroots* formation of the scene calls into question their dedication to, knowledge, or passion about the game and its community—an example of ongoing gate-keeping discourse. The contributions of *doc kids* to the competitive *SSBM* scene, however, cannot be understated—for example, Marth player "Zain" Naghmi, who began playing in 2014, was the first *doc kid* to win a *major*. Shine 2018, one iteration of a massively popular *Smash* tournament series held annually in Massachusetts.

The "Chaos Era" from 2013 to the present has seen four of the five gods retiring or taking a step back. In 2016, PPMD announced an indefinite break from *SSBM*, citing many health issues (Smith). Armada retired from competitive singles play in the fall of 2018 (Wolf). Mew2King continues to circulate in and out of tournaments, but has recently shifted his focus to working on his upcoming book as opposed to tournament play (Siuty). Mang0's results and commitment to *SSBM* have debatably wavered over the years; he now focuses more on his immensely popular Twitch stream (twitch.tv/mang0), or practice of broadcasting himself playing video games at home live, than on his results in bracket (Masters). Only Hungrybox has consistently continued to improve at the game, and he enters tournaments regularly to this day—this commitment to the game and to his own claim to being a top player has earned him the title of best *SSBM* player in the world on the Melee Panda Global Ranking (MPGR) going on three years now (Michael).

The community defines this time period as one of chaos due to a number of factors. At this point in its history, *SSBM* is arguably at its largest and most professionalized or mainstreamed. As many players, especially those who have been a part of the competitive *SSBM* scene for most of their adolescence or adulthood, are averse to altering the *grassroots* framework of participation in the scene, many of them continue to adhere to and rely on the etiquettes and norms of the community's original *grassroots* culture, unfettered by the expectations of civility, inclusion, and a more polished exterior that the commercialization of *SSBM* has introduced to the community at large. The aesthetics and narrative of the competitive *SSBM* scene have continually been pulled in two conflicting directions: *grassroots* and esports. Choosing one over the other could mean sacrificing the comfy, tight-knit, familial, everyone-knows-your-name attitude central to the *grassroots* aesthetic in favor of the expansion and potential for financial stability that transitioning to a more professional face affords. Moreover, as knowledge of in-game techniques becomes ever more advanced and universalized through the dispersion of this knowledge through new media, players' styles and choices are becoming more clearly defined than ever before.

As these eras of *SSBM* become more clearly defined, both by community-run resources online and the presences and voices of experts, narratives of inclusion and exclusion become louder and more present than ever. Dividing *SSBM*'s history into sections like this has proved incredibly useful for tracing discursive shifts in

the community and examining what changes occur within those windows. Even today, *SSBM* players and community members exist in a state of constant tension as they debate *SSBM*'s sustainability and future. Some believe the game is amazing, as alive as ever, and arguably in a better position now than ever before to support its upper echelon finanically and discursively. On the contrary, others argue that the game is too *broken* to play anymore—too far advanced for newcomers to pick up with ease, they may say—or that the scene has died, too sterilized and constrained by the pursuit of the *esports* aesthetic to be worth participating in anymore. For the players less interested in the game or community nowadays, a well-run tournament or a *hype*, or exciting, set broadcast for all of the internet to see often renews their interest in the game. Even then, colder, more boring games—metaphorically speaking—and venues literally cold in temperature, garnering complaints from spectators and players alike, occur all the time and leave many players feeling hopeless about *SSBM*'s current nature and its future.

Player Spotlight: PPMD

All that said, one "god's" hiatus during this most recent era of *SSBM* stands out to me more than the others: PPMD's departure from competitive *SSBM* left a lasting impact on the community. Players desperately miss his explosive gameplay and breadth of knowledge, especially after he took home first place at both Apex 2014 and Apex 2015. His kind nature and his narrative fueled by wholesome determination set him apart from other players and entities in esports whose behaviors were more transparently aligned with the toxic ideals of masculinity so often prominent in gaming and esports circles (see Homosociality, Gender and Technique). After he announced his departure from the competitive *SSBM* scene, rumors of his return would practically spread at every given turn due to the immense void in the scene's heart that his absence at tournaments had left behind. Even though he wasn't competing any more, however, he still found ways to contribute to the community: throughout his hiatus, he continued to answer questions from community members about Falco and Marth, two characters he played often that were generally accepted to be his best, in threads on Smashboards he'd started back in 2007 and 2009 called "Falco Discussion Thread" and "Carefully Ask EG.PPMD about the Tiara Guy" respectively. Eventually, PPMD started streaming on Twitch (twitch.tv/PPMD) in April of 2019, signal-

ling his return to the public eye, a decision instantaneously met with an outpouring of love and support from the competitive *SSBM* scene.

One of the reasons I admire PPMD and respect him so much as a *SSBM* "god", celebrity and example of a positive *gamer* identity is because of his commitment to grow and take care of himself. PPMD began his hiatus because he recognized that he recognized a disconnect between his mind, body, and energy, a common feeling for someone suffering from any chronic illness. After many doctors' visits, PPMD was diagnosed with low testosterone causing chronic fatigue. In an ESPN article around the time of his hiatus he explained:

> The bigger issue for me with breaks from competing is that many people think I get worse or think I am somehow not taking competition seriously, as if I would choose this way to live if I had a choice right now. The social isolation, admittedly somewhat self-imposed, somewhat necessary due to low energy, is hard. I miss my friends who live farther away. I miss my fans and being able to tell them good things. I miss being able to just compete and really being able to enjoy the thrill of it all. It cuts deeply when the artist cannot create. It's my art and without it I feel incomplete doing shoddy work. (W. Smith)

It is not only his introspectiveness and ability for self-reflection that make him special, it is his ability to articulate, teach and share these personal experiences with others. Author of this article and long-time community member, Wyton "Prog" Smith, puts it well by saying, "Honing his mind is where PPMD differs from most of his compa-

triots"—for example, as PPMD discusses in the article (W. Smith), he sustains a meditation practice, which he often discusses on his popular stream. His passion for acquiring knowledge and learning is an integral part of not only his identity as a *SSBM* "god" but also as a public figure performing online for his fans. PPMD's ethos is about evolution. I appreciate his ability to be candid with his audience and call out poor behaviour, like sexism or gatekeeping. I truly believe that, through his introspection and his practice of chal-

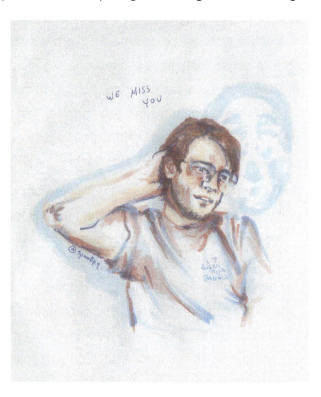

PPMD. Ink on paper. 2016.

lenging himself and others to be their best selves, he exemplifies what "being a *gamer*" could mean going forward. I personally wish him the best of luck on his journey, and I am excited to see how he continues to grow as a public figure in *SSBM*.

It Matters to Be Here

It is impossible to talk about *SSBM* without mentioning that while most esports can take place anywhere—given that they largely occur in online spaces with both players and audience at home—the majority of *SSBM* competition is contingent on players being in the same space as each other. Because Nintendo released the GameCube at a time when consoles did not yet boast innate wireless connectivity, to play *SSBM* competitively mandates that players play on the same console—often on the same television, so one has to sit right next to their opponent. Only rarely does the competitive scene host online tournaments on an emulator; due to the lag that emulated *setups* induce, these *setups* are seldom considered viable for competitive play—most results from online competition are not nearly as indicative of players' skill as results from in-person tournaments. As a result, *SSBM*'s early history is based in regional pride; as has been observed in many sports, players would travel from city to city and consider themselves proud representatives of their local community—regardless of whether their community knew they were being represented.

For *SSBM*, being present is a key element of being part of the community. Although Twitter and the increasing prevalence of livestreams have allowed people to participate without physically displac-

ing themselves to the venue, these forms of spectatorship performed solely online often receive scorn from more devout players.

Experiencing a pivotal tournament or match in person allows a member to accrue cultural capital, which they can leverage to position themselves as more of a fan than others. It is a point of pride or honour for many players to collect and display tournament badges and lanyards to broadcast that they attended events in person.

This is certainly true for me personally; I engage in the practice of keeping and bringing home each badge I wear for a tournament, because I believe that each badge acts as a vessel for the memories, *hype*, and lived experience of its corresponding event. I revisit those memories through the practice of storing these badges. Keeping a pile of past tournament badges may help them feel associated and immersed with a given gaming community, like *SSBM*. Given how tightly the competitive *SSBM* scene holds onto its *grassroots* narrative, these tokens of tournament participation act as physical representations of players' commitment to the community, the cultural capital they've amassed during their time in the community, and the memories they've formed as a result.

Being There: Reflections on Genesis 7

The Genesis series is one of the most notable *Smash* tournament series of all time. In January of 2020, I, along with the rest of Genesis' seventh iteration (G7)'s over two thousand attendees, journeyed to Oakland, California to play and celebrate *Smash*. I had previously attended a few *majors*, but this one felt different. I went into this experience with a number of quantitative questions and took several notes on and pictures of the areas in and around the venue. Some of my questions were: how do people enter and leave the space? Where do people stop or congregate? What booths or activities attract the most attention, and when? How is the venue organized and why? I was especially curious about the construction of the space, the temporal mapping of bodies, and how the *grassroots* and *esports* dichotomy weighs on the tournament.

Although I'd been to tournaments held in spaces on a similar scale, none occupied the area as compactly as G7. After collecting my badge, I passed through a minimal security screening and found myself walking down an aisle of individual booths known as the "artists' alley." Here, retailers sold fan art and custom works, such as posters, charms, stickers and pins, alongside questionably licensed paraphernalia like plushies and apparel. Other booths sold *modded* and handmade controllers, consoles, and peripherals.

Some *modders* brought in miniature soldering stations and assorted tools to help patrons replace components in their controllers. Players were quick to line up to get their controllers modified both to optimize play and to leave their mark on their hardware.

The oft-overlooked tension that existed between various controller *modders* on site is a direct result of the *SSBM* community's *grassroots* ideology. Players seem to prefer *modders* with cultural capital and long-standing community influence over strangers to the community, even the ones with flashier booths. Although all the booths boasting controller *mods*, custom controllers, and buttons presented themselves as experienced and competent, where the majority of players had placed their trust was evident: the line for company "Top Notch Controllers", headed and founded by the most favoured *modder* at that time, Noah Ray "N3zModGod" Valdez, was by far the longest, even well into the second day of the event. N3zModGod, who streams and *mods* alone out of his garage, ran a booth with similar hardware to the others, including wire frames laden with merchandise and social media banners. N3z's commitment to *SSBM* was displayed through his purchasing ad space on stream, in which he lists the *top players* who use his *modded* controllers. What truly set N3z apart from other *modders*, though, was his reputation: he infamously worked incredibly long hours in order to pursue both *modding* and streaming simultaneously at the cost of his physical and mental health, but in return, his efforts gained him favour amongst the upper echelon of players residing in southern California—one of the oldest

and most established regions in *SSBM*, also known as "SoCal". It's no secret in the community at large that the *SSBM* player base in SoCal specifically has maintained considerable influence over the rest of the scene for a very long time: Mang0, one of the aforementioned five "gods", has lived in SoCal throughout his entire *SSBM* career, along with several other players who consistently place high on the MPGR year after year. While this by no means discounts the work he put into popularizing *modding* and growing his business, the ways in which residing in SoCal and amassing favour with SoCal's finest have strengthened N3z's reputation in the community at large are hard to overlook.

Overall, the venue may value all *modders*, and demonstrates this by putting them at the forefront, but players clearly pick and choose their favorites. Past the artists' alley, a variety of rented arcade cabinets had been set up for free play. It was rare to see them not in use. Following the cabinets was the beating heart of the space: the desk of the tournament organizers, aka the TO desk. The desk is arranged in the centre of the venue, with several tables arranged in a square to keep the TOs' tools, files, snacks and belongings inaccessible to the rest of the attendees. There was a large touchscreen monitor in one corner that players could use to search for their match times and view the brackets. This is the space that holds the most power, as the TOs are the people who make everything happen. As described, running brackets, fielding logistical concerns, juggling the needs and wants of players with those of broadcasters or the

venue—responsibilities referred to colloquially as "TOing"—can be a strenuous and thankless undertaking, especially given that, even at big tournaments like G7, most of the work of TOing is performed by unpaid volunteers. Within the enclosure, I noticed supplies such as gummy vitamins, snacks, and water bottles; it's nice to know that the G7 organizers show some their appreciation and understand the strenuous job of the TOs.

All the space in front of the TO desk was dedicated to tournament play. Roughly sixty-four consoles—some Wiis, some GameCubes—were set up in front of CRTs and arranged to form eight stations of four consoles each. An additional at least half-dozen CRTs were either unplugged or hidden beneath a table. Because the consoles outnumbered the memory cards available, many of the *setups* were rendered unplayable—certain characters and stages considered tournament-viable can only be accessed either through unlocking them through hours of gameplay, or through loading a pre-existing "complete" (all characters and stages already unlocked) save file stored on a memory card onto the console. The lack of tournament-ready hardware adds additional complexity to the event, because this often leaves players in perpetual limbo, searching high and low for a free *setup*. While the ideal free *setup* is one with, at most, one other person on it for uninterrupted one-on-one free-play, more often than not, players are forced to join in on three-person rotations.

Depending on a variety of factors, one of two paths can be taken

IV. Discourse

here: either one plays two games in a sitting against each of their opponents and then temporarily excuses themselves from gameplay, regardless of who wins or loses, so as to let their opponents play one another, or the winner-stays-on method of rotation is adopted. The winner-stays-on method arguably promotes higher stakes than usually exist in free-play and entices players of more developed skill or game knowledge to continue "trying" versus potentially newer or less skilled opponents at the *setup*. That said, it is my belief that the practice of defaulting to winner-stays-on is an example of gatekeeping in competitive *SSBM* culture. It impedes newer players' ability to learn by allotting them fewer opportunities than more skillful or experienced players to try new things or, as is often the case at *majors* like G7, play against unfamiliar characters or styles of play.

G7 was sponsored by Nintendo—as were previous Genesis tournaments. Nevertheless, I didn't notice a strong presence from the colossal company. Nintendo had their logo beside the G7 logo on every stream backdrop, badge, and stream overlay, but aside from this, I didn't see any other visible representation or contribution. Of course, Nintendo has historically shown more evident support for *Super Smash Bros. Ultimate* and *Splatoon 2*, both of which were featured events at G7, so perhaps the presence of those events was more what motivated Nintendo's decision to sponsor G7.

Generally speaking, I have observed through my work with hardware and software in academic settings that Nintendo's policy is that all emulations of their games—running a copy of *SSBM* on

a Wii off of an SD card, for example—must be accounted for with a physical copy of the game. I have also observed that Nintendo has historically not responded well to the use of UCF (see *Snapback and UCF*) (I. Khan). While I assume that G7 was following through on the first policy, I question if Nintendo was aware that UCF was on several *setups* at the event, given that only two *setups* were broadcasted live. Unless Nintendo had a representative on site, they weren't likely to stumble across those *setups*, and it is my belief that this is what drives the recent precedent for tournaments that has come to fruition since Nintendo's public condemnation of UCF: attendees and TOs alike will purposefully not post or only vaguely post on social media about the presence of UCF at tournaments so as not to draw Nintendo's attention while signaling to other players that they will have the experience they expect (Buckley).

Nintendo aside, G7 was bustling with excitement. Practically every *major* has seen an upset or two at minimum in the bracket, the news of which can circulate quickly in the venue. Many players are averse to waking up before 10:00 a.m; the venue tends to fill up after lunch. By around 2:00 p.m. on the second day, I noticed exceptional excitement—or *hype*—in the space. Players hustled around to catch matches that weren't streamed, giving them a unique real-time experience that they could leverage as cultural capital, after the fact.

After two rounds of double-elimination pools, the number of competitors was narrowed down to the top sixty-four; this is where some of the most *hype*—that is, the most entertaining or unpre-

dictable—*SSBM* play is seen. Once there are eight players left, matchups admittedly become less exciting, since they feature the same players over and over. However, G7 made the top eight bracket special by relocating it to a theatre near the venue, a move unseen at most major *SSBM* tournaments. In the theatre, the division between spectator and competitor is propelled by the separation of audience from the stage. The grandness of the theatre, coupled with the high production quality of the broadcast for the audience watching from their phones and computers, emphasizes the celebrity status of *top players*—a reality often obfuscated by the emphasis on the *grassroots* feel of *SSBM* that many community members insist is an equalizing and unifying force.

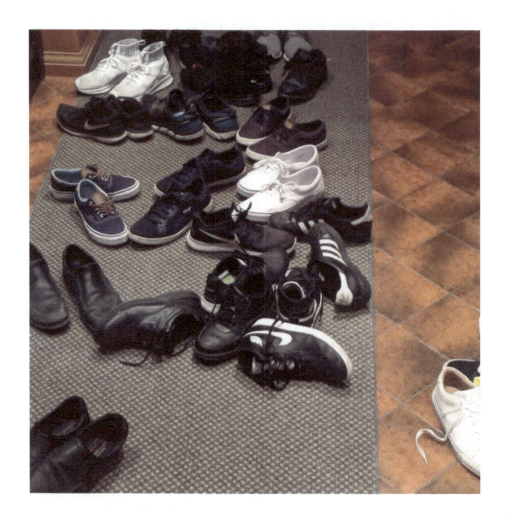

Players leave their shoes at the door at a *Smash fest* (circa 2018).

V. Technique

Examining *SSBM* Technique, Culture and Infrastructure

SSBM's growth as a competitive community emerged from players' explorations of the game's material affordances to create a variety of techniques or methods for doing things. The community's techniques and practices make up the fabric of contemporary *SSBM* culture, which I find worth analyzing because, as Raymond Williams explains, analyzing culture can open the door to discovering the nature of an organization. The meanings and values of a given group are kept alive through social inheritance and embodiment, and they are proven universal when they are learned—that is to say, they become real through being circulated through the community until the expectation to perform them becomes tacit and obligatory (Williams). Analyzing one technique can reveal others associated with it, if not outright information about the group as a whole, as Williams indicates. Moreover, Williams conveys the operation of selective tradition within a culture as a process that governs techniques by special interests of the group; techniques that were or are considered dead or abandoned become rediscovered and remixed to adapt to the contemporary moment.

The *grassroots* nature and shared practices of *SSBM* contend with methods of discourse and technique identified by gaming scholars Emma Witkowski and James Manning. As gaming scholars Emma

Witkowski and James Manning describe, there exists a common struggle between video game players and developers, or "those who code and determine the rules of play" (1). Their work observes the conventions of "high performance" players—those who pursue and "maintain excellence" (qtd. in Witkowski & Manning) in their play—and networked play practices, as well as their impact on the layers of interplay between a community centered around a game and that game's developers through a case study with Nintendo and *Super Mario Maker*'s networked community. In order to tackle this topic, Witkowski and Manning bring up the concept of co-creation, a term first coined by TL Taylor: how a game is played and the framing and maintenance of the game are not the sole responsibility of the developer, but instead a shared responsibility between players, developers, and technologies that perpetuates a sort of collaborative ecosystem (2). Witkowski and Manning emphasize the importance of co-creation in esports, specifically the relevancy and influence of knowledge holders; according to them, "co-creation renders visible the paradoxes of infrastructure, where the weight of change is loaded onto the players themselves" (13). However, while both *Super Mario Maker* and *SSBM* are properties of Nintendo, what sets *SSBM* apart from other esports described by Witkowski and Manning is that the responsibilities of defining "performances (on and off screen, by players and spectators), ownership/governance (of the game, of third-party organisations and products), and the expressions of player rights" (2) fall predominantly on the shoulders

of *SSBM*'s player base.

As a result, I argue that Nintendo's adversity toward competitive *SSBM* has galvanized the community into a strong desire that *SSBM* community members both own and broadcast their knowledge. However, because that antagonism has resulted in a dearth of involvement financially or culturally otherwise, the infrastructure that has formed in its absence has, historically, not prioritized players' rights, placing the onus to develop socio-technical infrastructure on players rather than the developer, unlike what has been seen in other esports such as *League of Legends* or *Overwatch*.

Looking at specific techniques within *SSBM* culture can reveal not only the systems of behavior that players value, but also how and why players adopt certain techniques. Given that the very existence of competitive *SSBM* is a subversion of the developers' intentions, it serves as a fascinating case study in esports.

Hidden Competitive Potential: The Beginnings

As previously described, shortly after *SSBM*'s release, players began to realize the game's competitive potential. They began developing advanced techniques and combinations of moves, which emerged alongside a budding competitive spirit shared by players around the world—all this despite Nintendo's intentions of creating a more friendly game geared towards casual familial competition at worst. One example of this circulation of techniques occurring within the U.S. specifically was the West Coast and East Coast playing together and building a rivalry between the two coasts' player bases (Beauchamp).

Today, numerous guides designed to help players hone their *SSBM* techniques can be found on YouTube channels like "SSBM Tutorials" or websites like Themeleelibrary.com. Most of the advanced techniques contained therein have emerged from glitches and experimentation. One of the most common techniques, the *wavedash*, is a positioning tool executed using three inputs: Y/X to jump, L or R to shield, and a downward diagonal push of the analog stick. The technique requires a lot of practice, but it's a crucial positioning tool for every competitive player. Unlike a regular dash, it doesn't turn a player's character around when moving backwards, which would take extra frames; it can position the player for forward-facing hitboxes

V. Technique

after successfully shielding an attack so that they can deal the most damage; and it's more versatile than a normal *spot dodge*—dodging in place, by simultaneously holding down and shielding—especially for characters that have very slow roll times.

Other advanced techniques reduce the time it takes for a character land back on the stage after an aerial attack, known as *landing lag*; one such technique is *L-cancelling*—inputting L/R, or pressing either shield button, within seven frames of an aerial attack to "cancel" its *landing lag*. Similar to *L-cancelling* is *jump-cancelling*, which affects gameplay in similar ways but can only be used in the case of certain moves and characters. Even a technique called *shield-dropping*—when a player drops through a platform while shielding in order to remove two frames from the dropping animation—could be considered a time-saver. These shortcuts, through their discovery and optimization by *SSBM* players around the world, have developed beyond mere glitches; because they speed up movement, combos, and overall gameplay, they have all become established techniques

Artist's Statement: What You See Isn't What You Get

Although subverting initial intentions for technology is a common trope in media history, the case for *SSBM* is particularly significant because of the irony at play: Nintendo's intention was to create a casual "children's party game" but, as those children grew up and embraced the competitive potential this game held, an active community of teen and adult players—the exact opposite of the game's intended audience—was born. *SSBM*'s competitive history was entirely driven by its players, who started in the home. Thus,

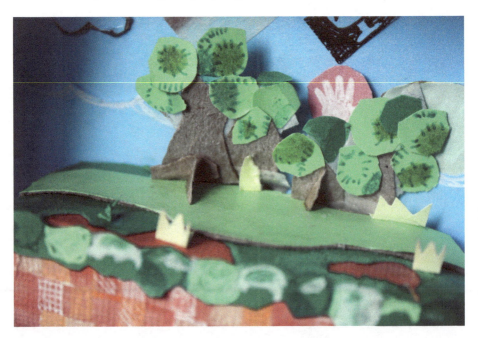

the competitive scene really did stem from Nintendo's familial and wholesome intentions. This piece is a replica of one of the game's few tournament-legal stages, "Yoshi's Story." It is my personal favourite stage to use because of its tight parameters and childlike aesthetics. My model of this stage is set in 4-3 ratio, just like in the game, but I've added half an inch to each side to allow more space for detail. The piece is made from household, elementary materials: construction paper, white glue, markers, pens, and cardboard. The use of these accessible materials is a way to reflect *SSBM*'s history of building something from the simple domestic space into something far-reaching and grandiose.

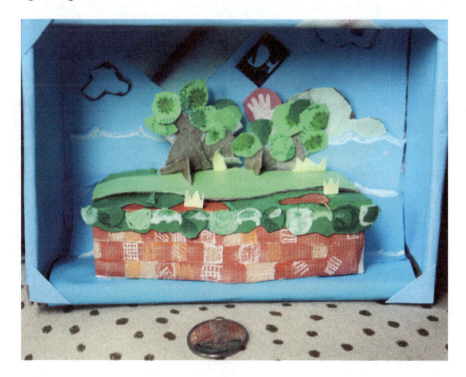

Practice Makes Perfect

The techniques of *SSBM* play are learned and internalized with practice. Most practice consists of repeating the timing, spacing, and inputs of various moves until they're etched into one's muscle memory. Practice is how competitive players distinguish themselves from casual ones. In her study of power gamers, TL Taylor describes the distinction between a casual and a power gamer in *Everquest*. Power gamers are dedicated to the backstory and narrative elements of a given game, and they attempt to prevent the lifespan of their game from ending. While they may accept a game's flaws, they never cease to push its limits. They are distinctly social and rely on others' information to improve their technical skills and accrue knowledge ("Power gamers" 307). Most, if not all, competitive *SSBM* players exemplify the ethos of Taylor's power gamers; however, there is no in-game story for them to worship and love. The love and passion are refocused on the narrative of one's own growth as a *SSBM* player.

SSBM players expect their peers to spend hours practising (grinding) their technical skills (tech-skill) in order to be considered part of the competitive *SSBM* scene. Through practice, players learn and discern the techniques of play within *SSBM* culture. Although most players may have their own practice regimes, players typically polish their movement, control, and tech-skill. Practice also takes

place outside of the home, at competitive events. Many matches begin with low-stakes practice rounds known as *handwarmers*, which serve as a way to reconnect and reintegrate the actions and feelings of play to the body. The notion and expectation of *handwarmers* realizes the impetus for practice. Here, players exhibit their personal practice drills, which other players can model.

Movement and Defensive Techniques

The following chart lists nearly every gameplay option that can be applied defensively. Of course, many *SSBM* and fighting game community members may argue that offense and defense are interchangeable. With this diagram, I am trying to trace the range of defensive gameplay options that players must learn, practice, and execute. Outsiders to this genre of game may regard fighting games as being based primarily on attacking, but to play *SSBM*—as well as other fighting games—competitively, one must learn all the tools that are available to them in play, including defensive options. Many characters have unique recovery options and special advanced techniques which *SSBM* players have discovered to be exclusive to that character. Those are omitted from this chart, because I'm more interested in outlining the universal techniques.

V. Technique

- **Positioning and Spacing**
 - Full Hop
 - Short Hop
 - Aerial Drifting
 - Walking
 - Dashing
 - Foxtrot
 - Dash Dancing
 - Wavedashing
 - Wavelanding
 - Pivoting
 - Moonwalking

- **Increase Speed**
 - Fast Falling
 - L/Jump/Auto Cancelling

- **Recovery and Post Knockdown Options**
 - Directional Influence (DI)
 - Smash DI
 - Automatic SDI
 - Teching
 - Wall Teching
 - Roll
 - Crouch Cancelling

- **Edge Options**
 - Edge Guarding
 - Ledge Dash
 - Edge-hogging
 - Sweet/Sour Spots
 - Ledge Refresh

- **Shield Options**
 - Light Shield
 - Power Shield
 - Spot Dodge
 - Air Dodge
 - Shield Toggling
 - Shield Grab
 - Moves Out of Shield (OOS)
 - Shield Drop
 - Wavedash Out of Shield

Player Identity Through Technique

Techniques of play can be the means to understanding what is important to a given community as well as an individual. Performing certain techniques in and out of play allows a player to align themselves with *SSBM* culture.

Picking a main character, or *main*, is for many *SSBM* players, their first form of self-expression through competitive play. Less than ten characters are viable for competition, according to community-developed tier lists, although some strong players have managed to excel with characters considered low-tier. Each character has their own weight, speed, move-set, frame data, overall flow and aesthetic; ergo, the act of selecting a *main* showcases a player's in-game priorities, as they are ultimately selecting the affordances of a given character. One's *main* ideally aligns with their predisposition to what they can do well; to choose a *main* is to make an attempt to align one's own strengths to those of a given character. More often than not, as a result, one's choice of *main* influences how they are perceived and judged by other *SSBM* players because of what their decision to choose a particular character supposedly says about them—it is often presumed that Captain Falcon *mains* chose their character so as to pursue a flashy and explosive play style; Princess Peach, a woman in a pink dress with a high-pitched voice, is often associat-

spoopy's tier list design. Ink and digital print (2020).

ed with femininity, leading to the decidedly problematic stereotype that any *SSBM* player who mains Peach on some axis deviates from the expectation that all *SSBM* players are male, heterosexual, and/or cisgender—although, notably, the weight or prevalence of this stereotype significantly diminishes when a Peach main is considered "good".

I would argue that these stereotypes about how players' personalities or identities correlate to their choice of *main* are rooted significantly more in presumption and anecdotal evidence than reality. That said, there does exist a sort of symbiotic relationship between players and their *mains*—the affordances of one's *main* can shape one's mindset regarding in-game play. Over time, executing advanced techniques unique to that character can become as automatic as walking or breathing. This process can even produce cyborg subjects—players merging with their *main* through this secondary method of self-expression. In her discussion of the cyborg, Donna Haraway examines how bodies and technology can merge in a way that grows one's potential for activity, in a way only achievable through the addition of technology to the self (Haraway). When we look at *SSBM*, we see that players not only use their controllers but also an on-screen extension of themselves, which can perform actions that the human body cannot, to achieve in-game activity.

The aforementioned techniques for play have become universal in competitive participation. Alongside these existing moves, various

other techniques that were discovered or perfected by individual players have also achieved universal recognition; one way that these techniques have become immortalized in *SSBM*'s history is the practice of naming them after said players: *Scar jumping, Hax dashing,* the *Ken combo,* the *Amsah tech, wobbling, Shino stalling,* the *PC drop,* and the *Isai drop* are all examples of this practice in action. This practice implicitly positions these individual players as experts in the community through directly acknowledging and crediting their initial discoveries, and it also reinforces the *grassroots* nature of *SSBM* by maintaining recognition of some of the community's earliest participants even as the community has grown and changed over time.

Various bodily techniques have also been attributed to individuals in the community. For example, the top ranked player, Hungrybox popularized standing while playing. It is unclear why he started standing while playing and he doesn't do it very much anymore, but his name is still referenced when people stand while playing. At one point, Hungrybox would stand midway through a set to show that he was changing his game-plan. Other players, like Cary "Vro" Zhang and James "Swedish Delight" Liu, are known for wearing sunglasses while playing or unconsciously having their tongue out during a match. Unique grips and stance display particular embodied and individualized senses of play.

Case Study: *Wobbling*

Many aspects of *SSBM* gameplay are notorious for being *broken*, but perhaps the most infamous case is *wobbling*. *Wobbling* is a technique whereby players can execute an infinite combination of attacks against their opponent, enabling them to deal unescapable damage up to 999% to the receiving player. The move is exclusive to the Ice Climbers character, the only character that is actually two characters at once: Popo, the lead climber who performs the player's inputs first; and Nana who executes the same input, but with a slight delay. When executed correctly, *wobbling* is an infinite grab whereby one climber grabs and the other tilts—performs a move triggered by the press of the A button—until the opponent is at a high enough percent to kill. The combo is topped off with a smash attack, sending opponents to the blast zone.

Wobbling relies on the ability to desynchronize (or *desync*)—that is, to input an attack while Popo isn't able to execute it but Nana is. For example, by performing a well-timed attack after dodging in place—also known as performing a *spot dodge*—only Nana will execute the attack ("*Wobbling*"). Although desyncing was first discovered in Japan, an American player, Robert "Wobbles" Wright, popularized it when he used it at the NorCal Tournament 2 in 2006.

To escape any grab in *SSBM*, players can mash buttons A, B, X,

Y, L, R, and Z—if timed right, players can reduce a grab's duration by 6 frames by mashing these buttons. The way this works is that there is a small window at the beginning of all character's grabs, whereby players can mash out; this entails rapidly pressing specific buttons so as to increase the chance of escaping a situation such as a grab. However, as this window is extremely small, it poses a difficult task. Nonetheless, mashing out has become a universally mandated technique for competitive play as *wobbling* has risen to power.

Wobbling is one crucial example of how the competitive *SSBM* community discovered and implemented an exploit in the game's software. It capitalizes on a unique form of grab *hitstun*—the moments after being hit by an attack in which a character is unable to act outside of directional influence or teching, a stun that renders the character incapable of escaping a *wobble*. The community tends to view this move as extremely overpowered (often abbreviated as OP), boring, repetitive, or thoughtless. For years, an ongoing debate about whether this technique should be banned in competitive play has raged on. Some *majors*, such as The Big House series, recently decided to ban *wobbling*, whereas others, such as the Genesis series, have allowed it to remain legal. Those opposed to the ban "claim that *wobbling* is a legitimate tactic, acting no different from infinite combos found in other fighting games, such as those found in *Marvel vs. Capcom 2*, or even *Melee*'s other chain grabs" ("*Wobbling*").

Notably, *wobbling* is similar to beloved community-developed techniques such as *wavedashing* and *L-cancelling* in that it is an exploit

of the game's software, not something deliberately programmed into the game by the developers. However, competitive *SSBM* players cherish those other techniques and would never dream of banning them. *Wobbling*'s notoriety and the case for banning it, therefore, stems more from the perception that it is uninteresting to watch, much less to be subjected to in-game by one's opponent, and it may deter new players from spectating, let alone playing, *SSBM* in the future.

The *wobbling* ban debate poses a larger question about who determines what types of gameplay are good or interesting, and how the *SSBM* community comes to consensus on such issues of rules and regulation concerning technique. The influence of the more popular voices in the community has historically shaped rhetoric and ideology, which subsequently becomes internalized as communal consensus—this can explain such instances as renowned player Jeffrey "Axe" Williamson posting on Twitter advocating for a *wobbling* ban in 2019 (Williamson). Posts such as these on social media have served as mechanisms for regulation that, ultimately, highlight power dynamics present within the community.

Even if *wobbling* is often frowned upon, it is a useful case for understanding the motivations and ideology that define *SSBM* culture. Through some players' opposition to *wobbling*, they not only imply that the game is meant to be spectated, but also indicate that the game requires interesting gameplay. Although wobbling achieves the same end, victory, that all competitors in *SSBM* are ultimately chasing, because its lack of "style" and creativity deviates from the

perceived "correct" way to play, many of those competitors wish to ban it.

Homosociality, Gender and Technique

SSBM players strive to perform and execute techniques at an elite level. These techniques, at their roots, are invented by long-time players, and circulated through tutorials. Thus, what is "good" in play and in attitude rests in the hands of the most prominent voices like *top players*, long-time community members, and TOs. What I want to examine, however, is how those influential voices are determined and chosen, and how the societal and cultural influences of the world outside competitive *SSBM* act upon those decisions

Competitive *SSBM*, like many other competitive video games, is far from immune to the influences of the outside world. For decades in the United States, advertising for video games has historically targeted a very specific demographic: male, heterosexual, white, middle-class (Kinder), and cisgender. This targeted advertising has seemingly proved incredibly successful; as research by Benjamin Paaßen et al. has observed, video games—and by extension, the presumed default identity of a gamer—are both strongly associated with men in particular (2). Although there have been concerted efforts to create space in *SSBM* for gender minorities, the vast majority of *SSBM* players are themselves heterosexual, cisgender men, if not also white and middle-class; this tendency towards homogeneity present in *SSBM*'s player base has profoundly impacted "the

construction of masculinities" (Taylor, Raising the Stakes 110) within the context of *SSBM*, as well as how gender and *SSBM* interact on a larger scale.

The construction and performance of masculinity within the context of video games is by no means an under-studied subject, especially given that a lot of video games are played exclusively online. As Natasha Chen Christensen describes in her study of a *Quake* server:

> Although interactions in cyberspace occur without the boundaries of the body that are usually used in developing masculinity, masculine identities are developed in cyberspace nonetheless. The possibility for transcending traditional definitions of manhood is available in the context of cyberspace interaction, however... [through their pursuit of competitive video games,] young men reproduce many of the same rites of masculinity that occur in sports and the military. (Christensen)

What sets *SSBM* apart from games such as *Quake*, however, is that the construction of masculinity that takes place within the context of *SSBM* occurs both online and offline—if not far more offline than most other competitive video games, due to the community's insistence on using residual hardware to facilitate proper competitive play. Because the presence of "real world" (Gray 63) indicators of one's body and identity, while never truly impossible to mask, are even more difficult to transcend or ignore in *SSBM*'s inherently liminal online/offline environment, the competitive *SSBM* scene is even more likely than other competitive video game communities to reenact and perpetu-

ate "enactments of masculinity... [defined] by an emphasis on power, success, and wealth" as have been observed in other similarly homogeneous communities outside of esports (Christensen). While I have no desire to demonize men through describing how masculinity is constructed and manifested in *SSBM*, it is important to acknowledge the negative and sometimes even dangerous nature of the construction and performance of masculinity in *SSBM*.

The sameness and subsequent unification and bonding through sameness that so many of *SSBM*'s male participants experience is a key facet of Eve Kosofsky Sedgwick's definition of homosociality; a male homosocial environment is a "male-dominated kinship system" (3) characterized by the prioritization of "male friendship, mentorship, entitlement, rivalry, and [interactions between or concerning] hetero- and homosexuality" (1). When masculinity is constructed or enacted in such an environment, it is usually for the benefit of other men or in an effort to gain validation from other men—which can lead to "great competition and the risk of failure" (Christensen). Where Sedgwick and other scholars have particularly found fault with such systems is that so often they serve as manifestations of patriarchy: "relations between men, which have a material base, and which, though hierarchical, establish or create interdependence and solidarity among men that enable them to dominate women" (qtd. in Sedgwick 3)—or, for that matter, any identity or group deemed in opposition to these relations.

Similarly harshly enforced binaries can be found throughout

SSBM culture, as has already been discussed in this book—*grassroots* versus *esports*, cool versus *campy*—and many *SSBM* players and enthusiasts find it difficult to define one side without factoring in its opposition. However, from Sedgwick's point of view, this is not a natural or inevitable consequence of male bonding as much as it is a failure of imagination: "it has apparently been impossible to imagine" (3) a manifestation of patriarchy through male homosocial environments that does not inherently oppress, marginalize, tokenize, or "other" people who fall outside of the homogeneity desired by those within the community.

My argument here, ultimately, is that the male homosocial environment formed in the *SSBM* community, as well as its interest in continually interpreting and narrativizing its own history—a history rooted, notably, in uniformity and masculinity—constructs a culture that harms and gatekeeps newcomers who aren't men, thereby hindering the community's growth. I've been playing in and attending *SSBM* events since early 2015 and, even today, it's rare that I attend an event without being dismissed as not a "true" (Paaßen et al. 2) player—through being ignored during a conversation between multiple men in which I am the only non-man present, for example. Although I consider myself a social person, many players' lack of tact has made me feel uncomfortable if not outright unsafe at most tournaments that I've attended. It's no secret, in part because of several painfully public revelations that have shaken the competitive *SSBM* community in recent years, that, in some cases, this lack of tact has

escalated into instances of sexual harrassment and even assault (D'Anastasio), most of which has been directed towards gender minorities in the community.

The most aggravating question I get asked at events is whether or not I play *SSBM*. Unfortunately, it's also one of the most common questions I hear. This is one example of how the homosocial environment of *SSBM* draws an exclusionary boundary: there are people who "look like" they play *SSBM*, and there are people who don't—people whose outward appearance or behaviours invite open speculation. When a man sits down to play *friendlies* at tournament with other men he does not already know, it is rare that they ask if the newcomer plays *SSBM*. It is just assumed. They might instead ask how long he has been playing *SSBM*, if they ask any questions relating to this subject at all.

Somewhat related, is the tendency of male players to attempt to "save" players who are not cisgender—in the context of competitive *SSBM*, this often manifests as informing players who are not cisgender men against their will about techniques they already know. In addition, one of the assumptions that circulates at tournaments is that women or queer attendees are there to support a boyfriend and have little interest in growing their own skill. Todd Harper defines this narrative as "infrequent but extant" (115). I argue that just because this narrative is extant doesn't mean that it should automatically be assumed of all gender minorities or queer people participating in *SSBM*, nor should it be considered a "bad" or "incorrect" way to

participate in the community—condemning people simply for spectating, especially people who video games traditionally haven't been targeted towards, is just another example of gatekeeping in *SSBM*; it is also worth noting that this active discouragement can stunt the growth of those spectators into, potentially, players.

Online spaces in the competitive *SSBM* scene present similar barriers for non-male community participants. In regional *SSBM* Facebook groups, many posts begin with "Hey fellas/lads/men." Although live broadcasts of the game on Twitch.tv have proven useful in lending exposure to the scene, the majority of popular streamers are men, who address their audience as "boys." This form of address is the direct consequence of the internalized presumption that only men play video games or take them seriously enough to pursue content for "hard-core" gamers (Paaßen et al. 3) such as posts in Facebook groups or live broadcasts.

Homosocial Technique Constructed by Players

As a general rule, the community is far more likely to listen to the opinions of players like the aforementioned "five gods" or those whose skill is otherwise validated by the Melee Panda Global Rankings (MPGR), the de facto official ranking of the top one hundred competitive *SSBM* players issued at the end of every year. These players' long history in the competitive scene, coupled with their skill and the sheer amount of knowledge of the game and community they have amassed as *top players*, allots them a greater measure of expertise.

As previously discussed, the homogeneity of the loudest voices in the community has a huge impact on community discourse and the formation of techniques. Although many of these players contribute meaningfully to the community—developing new techniques and introducing new perspectives—they nevertheless largely emulate existing behaviors. These community members have achieved a sort of celebrity status in part because of the affordances of online interactions that can reinforce their presence in the community; as previously discussed they are not only watched on stage but during their day-to-day lives through social media.

Case Study: Drinking Culture

Whether *top players* are conscious of it or not, their impact on the social aspect of *SSBM* culture has proved massive over the years—and I argue that with this impact comes a responsibility to the rest of the *SSBM* player base that is often ignored by *SSBM*'s upper echelon. For example, this can be observed in how drinking culture has pervaded tournaments and the social media presences of *top players* in *SSBM*. Drinking culture is by no means unique to *SSBM*; it is a commonly accepted facet of many communities outside of gaming, especially those whose demographics skew young and male, and to try to pin down the reason why drinking culture exists at all would be far outside the intended scope of this book. In addition, it is not my belief that all manifestations of drinking culture promote excessive drinking or other equally irresponsible behaviour—my concern lies exclusively with how and why the drinking culture of the outside world is reflected and magnified within *SSBM* culture.

Because most events take place at large convention centres that are near or attached to hotels that host hundreds—sometimes thousands—of players, many tournaments boast afterparties on the last night of the tournament equipped with bars or other methods of selling alcohol. While these afterparties are often monitored and regulated so as to prevent underage or otherwise irresponsi-

ble drinking, drinking also often takes place within the venues of major tournaments—albeit much more discreetly (e.g., players might conceal alcohol in opaque bottles so as not to alert the venue's security officers).

Sometimes, drinking in venues is openly encouraged. For example, at Smash Summit 9 earlier this year, Hungrybox was filmed encouraging Mang0 to drink in order to play *SSBM* well ("Melee"). Mang0 is an extremely popular player and streamer with a die-hard group of fans, and his love of alcohol is undeniably an aspect of his public-facing persona: on his popular Twitch stream, he celebrated his favorite football team's victory with several drinks and passed out on camera. He was banned from streaming for two weeks afterwards, apparently due to this display having transgressed against Twitch's terms of service (Goodling). Once his ban ended, however, his stream came back harder than before, with subscriptions and donations rolling in like wildfire.

Although I, like countless others who participate in the competitive *SSBM* scene, love to watch Mang0 play, I argue that this lifestyle and his public broadcasting of it encourages an amplified acceptance for drinking culture in the community in a way that can skew towards promoting the irresponsible. In 2018, longtime *SSBM* player, broadcaster, and beloved public community figure Alex "Alex19" Ruvalcaba reported having developed severe pancreatic and liver problems from "drinking... [enough to have induced] stress, anxiety, and [a lack of] sleep" (Ruvalcaba). While the community reacted predominantly

with love and support directed towards Alex19, as can be seen in the responses to Alex19's statement, some reacted with concern for Alex19's circle of close friends, including Mang0:

> Hopefully mango [sic] sees one of his best friends getting hit with this and it scares him... I know it's their thing and all but this community really cares about all of them so much. They are OG's of melee and it sucks to see Alex get hit with this. Hoping the best for team beer and Norwalk. (Pizzaweedman)

Mang0 and Alex19, along with several others in their circle, have been playing the game for over a decade. The reputation for authenticity that they've developed coupled with their high skill level and the ease with which they have fit into the existing homogeneity of the competitive *SSBM* scene have allowed for their heavily publicized endorsement of drinking culture to become accepted and even admired. This constant endorsement has since led to excessive, indulgent behaviour that has literally jeopardized the health of a beloved community figure. My argument is not only that this behaviour flourishes because of the homosocial, insular, *grassroots* nature of the competitive *SSBM* scene, but also that continuing to sanction this amplified, aggressive drinking culture is counterproductive to both the maintenance and the growth of the scene.

Money Matches and Meritocratic Ideals

When *SSBM* players have come to a point where they want to test or prove their skill, they will often challenge other players to a *money match*. *Money matches* are essentially a form of gambling: players set an amount of money on the line and determine a set count (e.g., best of three, first to five) ahead of time. To signify to onlookers that they are partaking in a *money match*, the players will often place the actual cash wagered on top of the *setup*—this signifier can prove useful in guaranteeing that spectators or other players looking to use the *setup* don't interrupt the match. *Money matches* are often taken much more seriously than casual play (*friendlies*) due to the heightened stakes of the match. These stakes, for many players and spectators, translate directly to *hype*.

Throughout competitive *SSBM*'s history, several iconic *money matches* have taken place that have been used to settle rivalries or put a definitive end to trash talk and animosity (see Homosocial Control Techniques: Trash Talk). One example put something even more valuable than money on the line. Long-time player, commentator and community figure Kashan "Chillindude829" Kahn penned and performed a diss-track—that is, a musical verbal attack against a person or group, with roots in 1970s hip-hop—called "Respect your Elders" targeting William "Leffen" Hjelte's rise to the top in 2015. The

appropriation of the diss-track is a useful reminder that no community is ever truly sealed off from the world around it and its influences, and it is an example of how popular *SSBM* players borrow from other models of celebrity behaviour.

Chillindude829 and Leffen butted heads both on- and offline, particularly with respect to the right to play the neutral Fox colour in-game, for both players mained Fox and used that default colour as opposed to the three alternate choices of colour provided in-game. Chillindude829 believed it was only right that he have exclusive ownership of the color, because he had been playing the character for longer, and he challenged Leffen to a match that would determine which of the two could never use the default colour in tournament again. He even played the track in the venue to put Leffen off his game. Undeterred, Leffen won 5-0.

Today, Leffen is considered a top five player globally, while Chillindude829 dropped to 57th in 2017 and wasn't ranked in 2018 (Lee et al.)—although I would be remiss not to mention his other contributions to the competitive *SSBM* scene, including his commentary, his active Twitch stream, and his participation in *The Smash Brothers'* narrativization of competitive *SSBM*'s history. Chillindude829's demonstrated resistance to Leffen's openly aggressive and competitive attitude at the time, plus his rapidly accelerating success as a player and community figure, is an example of how, as new players assimilate into the *SSBM* community, longtime community members often visibly and vocally struggle with accepting them into the existing

culture.

I wonder how this situation would have played out had Leffen not inherently exemplified the overtly competitive behaviour and profound technological literacy expected of a top player. *SSBM* players are often quick to dismiss the opinions, expectations, and behaviour of newcomers that can't prove their proficiency in or dedication to the game in some immediately tangible fashion. Should this attitude persist, I worry that this culture of gatekeeping and dismissal will further shut out people looking to participate in competitive *SSBM* going forward. This same attitude can also be observed in the way that community members who aren't competitors themselves are often looked down upon or viewed contemptuously by those who are. Because most fighting games don't feature teams larger than two people, it's easy to overlook the non-competitor. It is crucial for the competitive *SSBM* scene to learn to appreciate all the different roles in the community.

At the end of the day, *SSBM* players are united by their love for the game and their desire that its popularity persist. The more that *SSBM* community members proactively dedicate time and effort to fostering an inclusive and accessible attitude within the scene, the more likely such a bright and prosperous future for the game becomes. In order for the competitive *SSBM* scene to further its growth, the act of welcoming a diversity of perspectives needs to become a priority and an imperative—that, and reproducing the history of the scene in a way that retroactively acknowledges the privileges from which its

most successful or well-known community members have benefitted and how the longtime homogeneity of community demographics have reinforced these privileges.

Homosocial Control Techniques: Trash Talk

Any *SSBM* community member is aware of the *hype* and intensity that exciting players can bring to the community. Players can be considered exciting because of their gameplay, their overall aesthetic or style, or the narrative constructed around their play or personality. As has also been observed in many other sports and esports, spectators and other community members can become extremely passionate about certain players over others; they voice their opinions on their favourite—and, consequently, their least favourite—players through a number of performative actions, like cheering on their favourites or demoralizing their favourites' opponents through trash talk during the match. Even in a relatively small and tight-knit scene like the competitive *SSBM* scene, the majority of tournament sets, especially at major tournaments boasting over a thousand attendees, are played on a random *setup* somewhere in the venue, where anyone can easily walk up right behind the players and spectate from a vantage point unusual even to most esports—effectively nullifying the physical dividing line between player and audience. Many players, especially those who have been community members for a long time, argue that managing trash talk directed at you, whether online or yelled half a meter away from you, is an integral part of the *SSBM* player experience, yet, ultimately, it is a form of bullying.

SSBM players and spectators alike are often quick to voice their disappointment in a given player if they consider that player's actions in game to be "wrong", "bad", or "lame"; the ability to form an opinion on a given player is, in a way, a performance of one's knowledge of the "right" or "correct" way to play the game. While *top players* are often the players most subject to public scrutiny, trash talk, or criticism because of their celebrity status and extreme visibility, should they brush off the pressure of public scrutiny and continue performing well, they are rewarded: if they are to publicly scrutinize or trash talk another player or community member—especially if that person, say, ranks below them on the MPGR, or falls outside of the homogeneous majority demographic in *SSBM*—that criticism is often subsequently absorbed and parroted by the community at large. This kind of trash talk from community experts directed towards or at the expense of disempowered groups in *SSBM* can induce more adverse effects than the trash talk directed towards the experts from their audience at large:

> Though experts often appealed to the purity of their professional honesty to justify their claim to public recognition, they did not feel bound to practice the same honesty in their relations with stigmatized groups. Instances of deception and intimidation... were reported unselfconsciously and described as agreeably humorous, even morally essential when practiced by experts on these groups. (Marvin 35)

This arguably indicates a need among experts to single out margin-

alized groups as a means to reinforce their congruence with, power in, and significance to the competitive *SSBM* community—especially given that, as visible experts, they endure quite a bit of public scrutiny and criticism themselves that threatens their claim to expertise and their positive reputation amongst the *SSBM* community at large. Regardless, this system of using trash talk to put down players constructs lopsided power dynamics in the community and, instead of regulating or holding experts accountable, often results in the ostracization of marginalized or otherwise disempowered groups in *SSBM*.

Resistance to Homosocial Discourses

All this said, to paint the competitive *SSBM* scene as an impenetrably homogeneous community would be unfair to all of the players and community members who have either made incredible strides towards making the community more welcoming and accessible. Sasha "Magi" Sullivan, for example, was ranked 97th on the MPGR in 2018, marking the first time a woman and a transgender person had made it into the top one hundred (A. Lee).

In order to challenge the homosociality present in *SSBM* culture, some players and groups have turned to subverting existing community traditions. The crew battle is a long-standing tradition in competitive *SSBM* wherein evenly-numbered crews send in players to battle one-on-one until one crew runs out of players to send in. Beginning in 2017, an organization called Smash Sisters, headed by long-term *SSBM* players Lilian "Milktea" Chen and Emily "emilywaves" Sun, started hosting crew battles as events on the side at *majors*. These crew battles differed from previous iterations of the popular side-event in that they were intended exclusively for gender minorities in Smash. They aimed to bring new and veteran players together and encourage friendly competition; Smash Sisters crews are often based on region, providing a means for gender minorities in *SSBM* to unite with others nearby. These events have historically

proved incredibly successful and given marginalized players a chance to feel not only included, but prioritized, in an *SSBM* space. Milktea has also spoken about bringing empathy into gaming practices in order to address sexism in these spaces (Chen).

However, despite the events only being recorded and not streamed so as to prevent unmoderated live harassment of the crew battles' participants by viewers, non-participants have used this platform to compare women's skill and to determine "who is the best girl Smasher," a practice that is antithetical to the event's intentions. I look forward to seeing the way this event continues to shift community practice and create more space for all players to meet people and play together.

Moreover, Kyle "Dr. Piggy" Nolla's impact on the Smash Bros. community at large cannot be understated. For one, her academic background and ongoing research on gender, cognition, and video games stands to provide immeasurable insight into *SSBM* and its culture. Dr. Piggy was also one of the original co-founders of the SSB Conduct Panel and has remained its public face since its inception in 2019 (Weaver), a responsibility which has proved daunting and at times incredibly exhausting; the CoC, after all, operates with zero financial or otherwise infrastructural support from Nintendo, like most other entities and organizations in *SSBM*. Creating and upholding protocol for dealing with issues in the community such as sexism and harassment is no easy task, and I applaud the work Dr. Piggy

and others volunteering their time and energy on behalf of the CoC have put in.

Milktea. Oil on canvas (2019).

Continuing to Resist and Grow

As can be seen throughout this book, the competitive *SSBM* scene boasts an impressive and substantial lexicon unique to the community, complete with many traditions and assumptions implicit in one's use of language. For example, when playing *netplay*, a player might use he/him pronouns to describe their opponent despite having no knowledge of their opponent's pronouns, or someone commentating a live broadcast of a set may, out of habit, refer to both players with he/him pronouns. Both of these instances reveal an internalized association between video games and traditional masculinity (Paaßen et al., Kinder)—one that is by no means exclusive to *SSBM*. I suggest that the simple act of shifting one's instinct towards referring to others in the community by gender-neutral pronouns (they/them) first, as opposed to assigning gender without thought, helps break down the tacit expectation of homogeneity in identity. Instead of ostracizing gender minorities in the scene, this act of allyship includes and makes space for them.

Furthermore, I would refer people looking to make *SSBM* or any gaming space more inclusive to AnyKey, a self-described "advocacy organization" and former sponsor of Smash Sisters' crew battles. Founded in 2015, AnyKey's mission statement reads, "AnyKey's primary objective is to substantially increase diversity, inclusion,

and equity in competitive gaming" (AnyKey). They host a variety of resources for those who wish to amplify, connect and empower gamers from all backgrounds. I would direct anyone who reads this to take AnyKey's GLHF pledge, which is a promise to make a difference as a positive and inclusive member of a given gaming space. It is important to understand that diversifying this homosocial space is a process and that is okay.

At its roots, *SSBM* culture, much like those of virtually all other esports, is shaped by video gaming culture. Copious scholarly work has been published on the gendered advertising of Nintendo's video games, specifically in the United States, and its impact on the conceptualization of the ideal demographic for video games (Kinder), as well as concerning how gender is embedded in technology itself (Wajcman 146). Although Nintendo's marketing strategies have changed with the times, one can still see its residual impact—*SSBM*'s full title, after all, is *Super Smash* **Bros.** *Melee*.

Many gamers may overlook this history, arguing that those outside of the perceived (idealized) demographic should simply "get good" or that "they would compete if they were good enough." But Todd Harper's response to comments like this returns us to the issue of homosociality. These comments are reinforced by:

> repeated rhetoric about how the community is blind to ethnicity, gender, sexual orientation... all that matters is skill. This puts women players, in particular, in an interesting double bind: unacknowledged structural and cultural barriers act to keep many (not

all) women who want to compete away... yet their lack of presence is used as a backdoor justification for not just prevailing attitudes about women's skill or belonging in competitive culture, but also for the lack of women in the first place. (118)

In order to continue the resistance against the negative consequences of homosociality in *SSBM*, all community members—players and spectators alike—must stop pretending that these consequences don't exist, that they're not that big of an issue, or that they somehow aren't relevant to the broader discourse about the game or community. All the energy spent debating these points could ultimately be better spent, as Bo Ruberg emphasized in their keynote about diversity in esports, being an advocate for marginalized gamers and prioritizing making space for them (Ruberg).

Artist's Statement: The Wholesome Gaming Manifesto

The Wholesome Gaming Manifesto was a performance art piece I started in 2019. I presented myself as a gaming oracle in a hand-made cloak with several different wires and gaming accessories sewn into the fabric. I stood before an audience and read a speech with gusto and fierceness. The speech, entitled "a speech for the ages," was a call to action for the gamers of tomorrow, encouraging wholesome play over toxicity. Here is a section from the speech's introduction:

> In the Anthropocene Epoch of today, gamers are beginning to harmonize and become synonymous with mainstream culture. As consoles progress and franchises' game titles grow, so do we as gamers. Yet, vexing situations and disappointing developments seem to surface all too often in gaming communities. Gamers are often remembered as infused with rage, impotence, rampant sexism and other ill-favoured qualities.

This interdisciplinary theological movement is a call for change. No longer will there be gatekeepers, ostracizing gamers of infinite and expansive identities. No longer will antagonism and apathy be our signifiers. No longer will gamers be or be seen as distasteful.

This performance uses drama and rhetoric to remind audiences that gaming is not going away any time soon and should be handled

with care. As gaming practices like *SSBM*'s competitive scene continue to expand and change, I urge people to reflect on their own practices in these spaces. As esports becomes more of a dominant facet of popular culture, it is crucial that these practices are handled with respect, consideration, and empathy to ensure a sustainable, accepting, and approachable future.

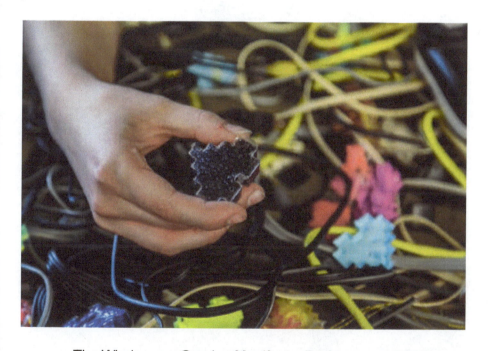

The Wholesome Gaming Manifesto. Performance (2019).

Documentation by Alex Apostolidis.

I PLEDGE TO SUSTAIN AND ENACT EMPATHY, SPIRITUALITY AND REFLECTION INTO MY GAMING PRACTICE(S). I HEREBY COMMIT TO BEING A WHOLESOME GAMER.

SIGNED: _____
DATE: _____

The Wholesome Gaming Manifesto: Oath Card. Print (2019).

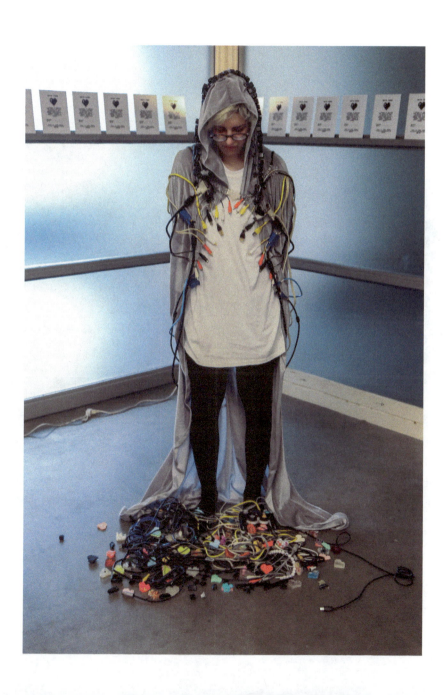

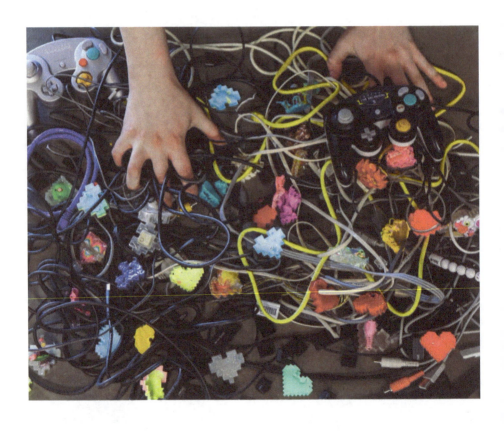

VI. Conclusion

By this point, *SSBM*'s hardware, software, and techniques have mutated far beyond their originally intended uses through competitive play—and this continued process of mutation shows no signs of stopping. *SSBM* is by no means a "solved" game, and I argue that the culture surrounding *SSBM*, if not gaming and esports in general, still has some growing and adapting to do itself. The evolution of discourse and technique specifically within the competitive *SSBM* scene invite speculation of *SSBM*'s staying power; *SSBM* is a game constantly in transition, guided by the values and principles of a community that continues to be hindered by Nintendo's antagonistic lack of support. Will *SSBM* ever stabilize? What would stability even look like for a community that has thrived on constant change and evolution for nearly two decades?

As things stand right now, it is a lot of work for *SSBM* competitors, even those performing within the highest echelon of skill and recognition currently achievable, to achieve lasting stability through competing in *SSBM*. Many *top players* feel obligated to create brands for themselves in order to seek out and retain loyal audiences. As a result, they deeply embed themselves in the world of social networking, new media, and performance. While some have secured sponsorship from big-name esports teams—support that translates

directly into financial stability, assistance with social media, and other perks crucial to sustaining their celebrity statuses—not all are so fortunate; most players who are free agents (i.e., unsponsored) act as their own managers. Many "legends" of *SSBM* have since retired to settle into more reliable careers. Others still attempt to lead a double life: working full-time during the week and catching redeyes to tournaments over the weekend. Will *SSBM* ever become a reliable source of income, as other esports have through developer support?

In March of this year, the announcement of the Smash World Tour (smashworldtour.com) attempted to answer this question. The Smash World Tour was intended as a circuit for both *SSBM* and *Super Smash Bros. Ultimate*, run and sponsored by the heads of VGBootCamp, one of the oldest *grassroots* organizations in competitive *Smash*, The combined starting prize pool for this year-long event was going to be $250,000, the largest amount in *SSBM*'s history. The circuit was intended to span internationally; any tournament boasting more than 32 entrants would have been able to opt in to have its results counted towards players' 10-month-long process of qualifying for the finals. This would have marked a huge step forward for *SSBM*'s recognition as a legitimate and professional esport— had it not been shuttered almost immediately after its debut due to COVID-19 concerns. At the time of this writing, Nintendo has yet to publicly respond to the proposition of this new circuit, but I wonder whether they support this development and whether they'll involve themselves in whichever alternatives to this circuit may be intro-

VI. Conclusion

duced in the future.

Some argue *SSBM* is a perfect game; others say, "*Melee* is *broken*." Many players say both. I have no doubt that *SSBM* community members will continue to debate how to best play competitively as long as the game is "alive". The liveliness and persistence of these debates is how so many have historically demonstrated their loyalty and devotion to *SSBM*; through researching this game and its community, pursuing my master's degree and thesis, and creating this book, I demonstrate my own. This is my love letter to *SSBM*. In this book, I have presented a number of critiques of and alternatives to current behaviour in and the current state of *SSBM* that I have observed both in and out of game. As I see it, when you love something, the best way to care for it is to invest in its improvement and development. I hope that my work here provides a scaffold for deep reflection and awareness to all aspects of *SSBM* as an esport.

Afterword
Nicole "st. nicholas" Bennett

The year is 2015. Fox and Falco are duking it out on Yoshi's Story at some random local; a guy in my dorm at Oberlin College has the live broadcast projected onto the wall of his room. A few doors down, I'm holding someone's spare GameCube controller and tapping the analog stick to make Dr. Mario waddle back and forth. My friends, who grew up playing the game and are now competent enough to play competitively, bicker over which combination of buttons should be taught to me first. I've never played *SSBM* before, and this is only my second time holding a GameCube controller.

Of course, that second time leads to a third, and then a fourth, and then a foray into the heady, explosive world of competitive *SSBM* that has more or less ran my life for the past five years. Admittedly, I spent only a small percentage of that time competing; while the seemingly limitless potential for self-expression that *SSBM* boasts never fails to reel me back in if I've spent some time away from it, I'll be the first to admit: competing in a game this complex is a demanding, punishing endeavor that I personally only ever found occasionally rewarding.

Nevertheless, practicing *wavedashes* in my basement for hours only to lose over and over again to the players of my local scenes taught me a lot. Writing had come easily to me my whole life, but now there was this challenging, unintuitive—and ferociously addictive—

animal of a game, daring me to try to wrap my head around it. I had to learn how to lose—and, eventually, how to win. How to accept failure and struggle as a necessary part of growth, instead of stubbornly resisting them just to appease my ego. How to ask questions, instead of making assumptions, and how to track down the right people to ask.

Learning *SSBM* taught me how to learn. While I might have eventually ran into these same issues and been forced to reckon with them through pursuing another medium, I certainly wouldn't have reaped the same rewards: through competing in *SSBM*, I've met hundreds of amazing people, many of whom I now consider friends for life. I've gotten to travel across the continental U.S.; in my five years of play, I've attended *SSBM* tournaments in Ohio, Michigan, Pennsylvania, New Hampshire, Massachusetts, Maryland, Virginia, Georgia, Arizona, and California. I've even gotten to support others in the competitive *SSBM* scene as an editor for MPGR and, more recently, as an event organizer for Smash Sisters. In fact, that I got to work on this book with AJ is yet another example of *SSBM*'s positive impact on my life, for which I am indescribably grateful—and to think that, less than a year ago, we were searching for a free setup at Genesis 7 together...

I grew up in a progressive, majority white part of the country. While I considered myself informed enough about issues of oppression such as racism, sexism and classism, I personally, for example, had never really felt ostracized solely because of my gender. Traveling for

SSBM enabled me to get outside of my "bubble" and meet all kinds of people whose identities, lives, and perspectives differed from mine. Through this process, I've gained a lot of insight into politics, culture, and how other people exist in and think about the world—insight that I doubt I could have cultivated any other way. To this day, I find it amazing that people from so many different walks of life are consistently able to find common ground with one another through playing *SSBM*.

I often think of *SSBM* as a mirror: when you play the game, when you go to tournaments, whatever is going on in your life or in the world around you gets magnified and reflected back at you. The way I see it, it's no coincidence that the players angriest after a loss are usually the ones struggling the most, be it with improvement, an internal conflict, or a situation at home; even though many people, myself included, have used *SSBM* as a means of escape from those struggles, the unique blend of community and competition that *SSBM* provides ultimately ends up bringing those struggles into focus, no matter their size. This meant that I was no longer a passive observer of sexism, but instead its direct target; since I started going to tournaments bigger than those at my college at the age of seventeen, I've been singled out, threatened, condescended to, followed around venues, and frequently subjected to harassment both online and in person, often of a sexual nature.

It remains difficult for me to reckon with this even now, given *SSBM*'s predominantly positive impact on my life, but the hurt, the

fear, and the feelings of powerlessness that have resulted from this harassment will most likely mar my relationship to *SSBM* for the rest of my life. It unnerves me that this same experience could remain a prerequisite for people outside of *SSBM*'s traditional demographic looking to assimilate into the scene. However, I am optimistic: as *SSBM* has reflected injustice, so it has reflected the gradual shifts towards more inclusive attitudes and actions that are happening in so many other communities right now. Seeing as how the competitive *SSBM* scene has not only adapted to the changing circumstances of residual hardware availability, but also maintained its unique longevity because of those adaptations, it is my belief that a brighter future for the game and the community is indeed possible.

The other night, after AJ and I had been working on the book for a few hours, I did something I haven't done in a very long time: I picked up my controller, logged into my Slippi account, found random people willing to play, and played with them. Above all, I hope this book inspires you to do the same.

Afterword

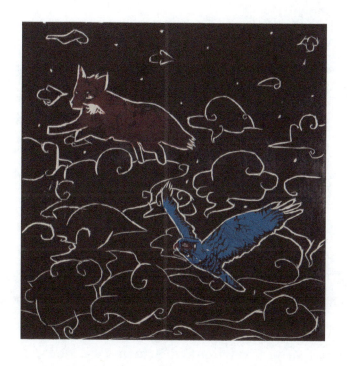

Spacies Having Fun. Reducting woodcut print. Edition of 6. 2015.

Works Cited & Bibliography

Acland, Charles R., editor. *Residual Media.* University of Minnesota Press, 2006.

Al-Yami, Aziz. "how to host *SSBM* tournaments without CRTs." *YouTube,* 22 Oct. 2019, www.youtube.com/watch?v=J6B4t5f-CEbQ. Accessed 6 November 2019.

AnyKey. AnyKey, www.anykey.org/en. Accessed 28 February 2020.

Apperley, Thomas and Jussi Parikka. "Platform Studies' Epistemic Threshold." *Games and Culture,* vol. 13, no. 4, 2018, pp. 349-369. *SAGE Journals,* doi:10.1177/1555412015616509.

Bassett, Mike. "ANALOG STICKS: Understanding, testing and troubleshooting your controller's most important part." *Melee It On Me,* 9 Nov. 2016, www.meleeitonme.com/analog-sticks-understanding-testing-and-troubleshooting-your-controllers-most-important-part.

Beach, Emily. "The History of Flat Screen TVs." *Techwalla,* Leaf Group Ltd., www.techwalla.com/articles/the-history-of-flat-screen-tvs.

Beauchamp, Travis, director. *The Smash Brothers.* East Point Pictures, 2013.

Bogost, Ian. "Against Aca-Fandom." 29 Jul. 2010, bogost.com/writing/blog/against_aca-fandom.

Boym, Svetlana. "Nostalgia and its discontents." *The Hedgehog Review,* vol. 9, no. 2, 2007. *Gale Academic OneFile.* Accessed 27 November 2019.

Bryce, Mio. "Cuteness needed: the new language/communication device in a global society." *International Journal of the Humanities,* vol. 2, no. 3, 2006, pp. 2265-2275.

Buckley, Brian (@Brian_Buckley). "Can't say TOO much on social media... But it's the answer you want it to be. (unless you're n0ne)." *Twitter,* 13 November 2019, 6:02 PM.

Christensen, Natasha C. "Geeks at play: Doing masculinity in an online gaming site." *Reconstruction,* vol. 6, no. 1, Winter 2006, https://web.archive.org/web/20130521043309/http://reconstruction.eserver.org:80/061/christensen.shtml. Accessed 21 May 2013.

Chen, Lilian. "How I responded to sexism in gaming with empathy." TEDYouth, November 2014, Brooklyn, NY, www.ed.ted.com/lessons/how-i-responded-to-sexism-in-gaming-with-empathy-lilian-chen. Conference Presentation. Accessed 16 October 2019.

Custodio, Alex. "The (After)Lives of the Game Boy Advance: Emulation, Embodiment, and Nostalgia." R-CADE Symposium, April 2018, Camden, NJ. Paper Presentation.

D'Anastasio, Cecilia. "The Super Smash Bros. Community Reckons With Sexual Misconduct Allegations." *Wired*, 10 Jul. 2020, www.wired.com/story/super-smash-bros-sexual-misconduct. Accessed 29 October 2020.

Doolan, Liam. "Masahiro Sakurai Isn't Concerned About Competitive Aspect Of Super Smash Bros." *Nintendo Life*, 8 Jul. 2018, www.nintendolife.com/news/2018/07/masahiro_sakurai_isnt_concerned_about_competitive_aspect_of_super_smash_bros. Accessed 20 June 2019.

Ernst, Wolfgang. "Media Archaeography." *Digital Memory and the Archive*, edited by Jussi Parikka, University of Minnesota Press, 2012. *Minnesota Scholarship Online*, doi:10.5749/minnesota/9780816677665.001.0001.

Elsaesser, Thomas. "Media archaeology as symptom." *New Review of Film and Television Studies*, vol. 14, no. 2, 2016. *Taylor & Francis Online*, doi:10.1080/17400309.2016.1146858.

"Events." *Major League Gaming*, www.majorleaguegaming.com/events/75/mlg-world-finals?utm_source=SmashBros&utm_medium=NP. Accessed 10 February 2020.

Foucault, Michel. *Archaeology of Knowledge*. 1969. 2nd ed., Routledge, 2002.

Foucault, Michel. "On the Archaeology of the Sciences: Response to the Epistemology Circle." *Aesthetics, Method, and Epistemology*, edited by James D. Faubion, The New Press, 1999, pp. 297-333.

Goodling, Luke. "Cloud9 pro Smash player banned on Twitch after passing out on stream." *Dot Esports*, 7 Jan. 2019, www.dotesports.com/culture/news/cloud9-pro-smash-player-banned-on-twitch-after-passing-out-on-stream. Accessed 15 October 2019.

Gray, Kishonna L. "Solidarity is for white women in gaming." *Diversifying Barbie and Mortal Kombat*, edited by Gabriela T. Richard et al., Carnegie Mellon University ETC Press, 2017, pp. 59-70.

Haraway, Donna. "A Cyborg Manifesto: Science, Technology, and Socialist-Feminism in the Late 20th Century." *The International Handbook of Virtual Learning Environments*, edited by Joel Weiss et al., Springer, 2006, pp. 117-158. *SpringerLink*, doi:10.1007/978-1-4020-3803-7_4.

Hicks, Marie. "Against Meritocracy in the History of Computing." *Core Magazine,* 2016, computerhistory.org/core-magazine. pp. 28-33.

Jenkins, Henry, et al. *Participatory Culture in a Networked Era: A Conversation on Youth, Learning, Commerce, and Politics.* Polity, 2015.

Khan, Imad. "Q&A with Nintendo at E3 -- The future of esports." *ESPN.com*, ESPN, 15 Jun. 2018, www.espn.com/esports/story/_/id/23804948/qa-nintendo-e3-future-esports.

Khan, Kashan. "Respect Your Elders." *YouTube*, 30 Jan. 2015, www.youtube.com/watch?v=KhsOW-_TwfU. Accessed 3 November 2020.

Kinder, Marsha. *Playing with Power in Movies, Television, and Video Games: From Muppet Babies to Teenage Mutant Ninja Turtles.* University of California Press, 1991. *UC Press E-Books Collection, 1982-2004,* www.ark.cdlib.org/ark:/13030/ft4h4nb22p. Accessed 3 November 2020.

Kirschenbaum, Matthew G. *Mechanisms: New Media and the Forensic Imagination.* MIT Press, 2007.

Laferriere, Jas. "Ugh, This TV Lags!" *Melee It On Me,* 27 Mar. 2014, www.http://www.meleeitonme.com/this-tv-lags-a-guide-on-input-and-display-lag.

Lee, Alex. "Smashin' the Closet: The story of the first trans player in Melee's top 100." *GameTyrant*, 31 Jan. 2019, www.gametyrant.com/news/smashin-the-closet-the-story-of-melees-first-trans-top-100-player.

Lee, Daniel. "Doc Kids basically represent people who got into the game after Aug 2013 in light of the Smash Documentary." *Twitter*, 15 Nov. 2016, 6:28 p.m., www.twitter.com/tafokints/status/798669118169722880.

Lee, Daniel et al. "*SSBM*Rank 2017: 60-51." *Red Bull*, 9 Jan. 2018, www.redbull.com/us-en/*SSBM*rank-2017-60-51. Accessed 3 February 2020.

"Major League Gaming." *SmashWiki*, www.ssbwiki.com/Major_League_Gaming. Accessed 3 November 2020.

Mallory, Jordan. "EVO 2013 charity drive raises over $200,000, Smash Bros. Melee final game selection." *Engadget*, 1 Feb. 2013, www.engadget.com/2013-02-01-evo-2013-charity-drive-raises-over-200-000-smash-bros-melee-f.html.

Marvin, Carolyn. "Inventing the Expert." *When Old Technologies Were New: Thinking about Electric Communication in the Late Nineteenth Century*, Oxford UP, 1988.

Masters, Tim. "The Mango [sic]: Why Melee is great, but not lucrative." *Luckbox*, 10 Jun. 2019, www.luckbox.com/esports-news/article/the-mango-why-melee-is-great-but-not-lucrative.

"Melee: The Next Generation - Smash Summit 9." *YouTube*, uploaded by Beyond the Summit - Smash, 15 Feb. 2020, www.youtube.com/watch?v=BgTdkIB_01E. Accessed 28 February 2020.

Michael, Cale. "Hungrybox named the best Super Smash Bros. Melee player for the third year in a row." *Dot Esports*, 24 Jan. 2020, www.dotesports.com/fgc/news/hungrybox-named-the-best-super-smash-bros-melee-player-for-the-third-year-in-a-row. Accessed 15 October 2019.

Miyake, Kuriko. "Flat panel TVs just keep getting bigger." *CNN.com,* CNN Worldwide, 3 Oct. 2001, www.cnn.com/2001/TECH/ptech/10/03/larger.flat.panel.idg/index.html. Accessed 15 November 2019.

Morrison, Sean. "Smash Sisters events invite women gamers to play, connect and smash." *ESPN.com,* ESPN, 28 Mar. 2017, www.espn.com/espnw/culture/feature/story/_/id/19027670/smash-sisters-events-welcome-women-play-connect-smash.

Myers, Maddy. "Time Is Running Out For The Super Smash Bros. Scene's Favorite Game Controller." *Kotaku,* G/O Media, 26 Sep. 2017, www.compete.kotaku.com/time-is-running-out-for-the-super-smash-bros-scenes-fa-1818815657.

Murray, Sean. "Smash Melee Legend PPMD Is Streaming Again." *TheGamer,* 29 Apr. 2019, www.thegamer.com/smash-melee-ppmd-streaming.

Nestico, Andrew et al. "#MPGR2018: 100-91." *Red Bull,* 31 Jan. 2019, www.redbull.com/us-en/mpgr-2018-100-91. Accessed 4 November 2020.

Nestico, Andrew et al. "#MPGR2019: 50-41." *Red Bull,* 20 Jan. 2020, https://www.redbull.com/us-en/mpgr-2019-50-41. Accessed 4 November 2020.

Paaßen, Benjamin, et al. "What is a True Gamer? The Male Gamer Stereotype and the Marginalization of Women in Video Game Culture." *Sex Roles*, vol. 76, April 2017, pp. 421–35, doi:10.1007/s11199-016-0678-y.

Pizzaweedman. Comment on "Alex19 has created a GoFundMe for his hospital bills." *Reddit*, 07 Jun. 2018, www.reddit.com/r/smashbros/comments/8p4oq7/alex19_has_created_a_gofundme_for_his_hospital/e097fu6. Accessed 29 Oct. 2020.

Radway, Janice A. "Women Read the Romance: The Interaction of Text and Context." *Feminist Studies*, vol. 9, no. 1, 1983, pp. 53-78. *JSTOR*, doi:10.2307/3177683. Accessed 4 Nov. 2020.

Ruberg, Bo. "Diversity and Esports: Video Game Culture, Collegiate Play, and Live Streaming." UCI Esports Conference 2019, October 2019, Irvine, CA. Keynote Address.

Ruvalcaba, Alex. "Here [sic] what happened, super grateful for my friends family and fans/viewers/supporters this was a big one for me. Thankfully I made it." *Twitter*, 2 Jun. 2018, 9:07 p.m., www.twitter.com/mach1alex19/status/1003080618614276096.

Salvato, Dan. "Universal Controller Fix." *20XXTE*, www.20xx.me/ucf.html.

Siuty, Luke. "Jason 'Mew2King' Zimmerman is working on a book about his life and Super Smash Bros." *Shoryuken*, 17 May 2018, www.shoryuken.com/2018/05/17/jason-mew2king-zimmerman-is-working-on-a-book-about-his-life-and-super-smash-bros.

Skler. "MBR Official Rule Set." Smashboards, 1 Dec. 2009, www.Smashboards.com/threads/mbr-official-rule-set.257229. Accessed 4 November 2020.

Smith, Chris. "Retro Tech - the CRT TV." *BT.com*, BT Group, 24 Feb. 2017, www.home.bt.com/tech-gadgets/television/retro-tech-the-crt-tv-11363858003032.

Smith, Wynton. "The battle in and out - Kevin 'PPMD' Nanney." *ESPN.com*, ESPN, 19 Feb. 2016, www.espn.com/esports/story/_/id/14806799/the-battle-kevin-ppmd-nanney.

"*Super Smash Bros. Melee* in competitive play." *SmashWiki*, www.ssbwiki.com/Super_Smash_Bros._%20Melee_in_competitive_play. Accessed 21 October 2019.

Taylor, T.L. "Power gamers just want to have fun?: instrumental play in a MMOG." *DiGRA '03 - Proceedings of the 2003 DiGRA International Conference: Level Up*, vol. 2, DiGRA, 2003. *DiGRA*, www.digra.org/wp-content/uploads/digital-library/05163.32071.pdf.

Taylor, T.L. *Raising the Stakes: E-Sports and the Professionalization of Computer Gaming*. MIT Press, 2012.

Thespymachine. "Melee 'Genealogy' - A Unique History of Melee." *Smashboards*, 4 Jan. 2014, www.Smashboards.com/threads/melee-genealogy-a-unique-history-of-melee.345237. Accessed 4 November 2020.

Wajcman, Judy. "Feminist theories of technology." *Cambridge Journal of Economics*, vol. 34, no. 1, January 2010, pp. 143-152. *Oxford Academic*, doi:10.1093/cje/ben057.

Walker, Ian. "*Melee* Player Quits Match Over Opponent's Jigglypuff Stalling." *Kotaku*, G/O Media, 1 Apr. 2019, www.kotaku.com/melee-player-quits-match-over-opponents-jigglypuff-stal-1833725878.

Weaver, Jackson. "How one video game community is trying to 'police itself' amid sexual assault allegations." *CBC*, 9 Jul. 2020, www.cbc.ca/news/technology/super-smash-allegations-1.5640449.

"Wii specs vs. GC specs....tell me the Wii is another GC now." *GameSpot*, 2007, www.gamespot.com/forums/system-wars-314159282/wii-specs-vs-gc-specstell-me-the-wii-is-another-gc-25539714. Accessed 3 November 2020.

Williams, Raymond. "The Analysis of Culture." *Cultural Theory and Popular Culture: A Reader*, edited by John Storey. 3rd edition, Pearson Education Limited, 2006.

Williamson, Jeffrey. "Wobbling needs to be banned. I've said this for years. It's pretty terrible for the integrity of competitive Melee. Near 0 risk, easy execution, 0 defense options. I was surprised when it was legalized again, with people just saying 'well, IC's aren't winning anything anyway.'" *Twitter*, 7 February 2019, 3:33 PM. www.twitter.com/TempoAxe/status/1093608628974567424.

Witkowski, Emma, and James Manning. "Playing with(out) Power: Negotiated conventions of high performance networked play practices." *Proceedings of DiGRA International 125 Conference*, 2017. *DiGRA*, http://www.digra.org/wp-content/uploads/digital-library/112_DIGRA2017_FP_Witkowski_High_performance_Play.pdf.

"*Wobbling.*" *SmashWiki*, www.ssbwiki.com/Wobbling. Accessed 25 November 2019.

Wolf, Jacob. "Armada announces retirement from Super Smash Bros. Melee singles." *ESPN.com*, ESPN, 18 Sep. 2018, www.espn.com/esports/story/_/id/24724988/armada-announces-retirement-super-smash-bros-melee-singles.

Yao, Richard. "Gaming as a Cultural Force." *Medium*, 15 Nov. 2018, www.medium.com/ipg-media-lab/gaming-as-a-cultural-force-dc-456f8a41ab. Accessed 10 February 2020.

Zielinski, Siegfried. *Deep Time of the Media: Toward an Archaeology of Hearing and Seeing by Technical Means*. MIT Press, 2006.

About the Author & Artist

AJ "spoopy" Rappaport (they/them) is a queer artist from Toronto, Canada. They completed their BFA in Studio Arts in 2018 and Individualized Master's in 2020. Their art practice spans across a range of mediums, specifically drawing, printmaking, oil painting, digital print, and sculpture. They have an interdisciplinary creative process and are always looking new ways to synthesize mediums together in new harmonies. Their projects are often inspired by nostalgia and early Internet, networked community culture and evidently, videogames. As well, they believe strongly in object-oriented ethnography, which explains that objects have a social life and influence on the humans that surround them. They seek to breathe life into otherwise perceived inanimate objects to bring a new sense of sociability and community to things other than bodies.

More details on and examples of their art practice can be seen on their website, www.spoopy.ca, on their Instagram page (@spoopy.online), or on their Twitter (@spoo0py).